LAKOTA HEALING

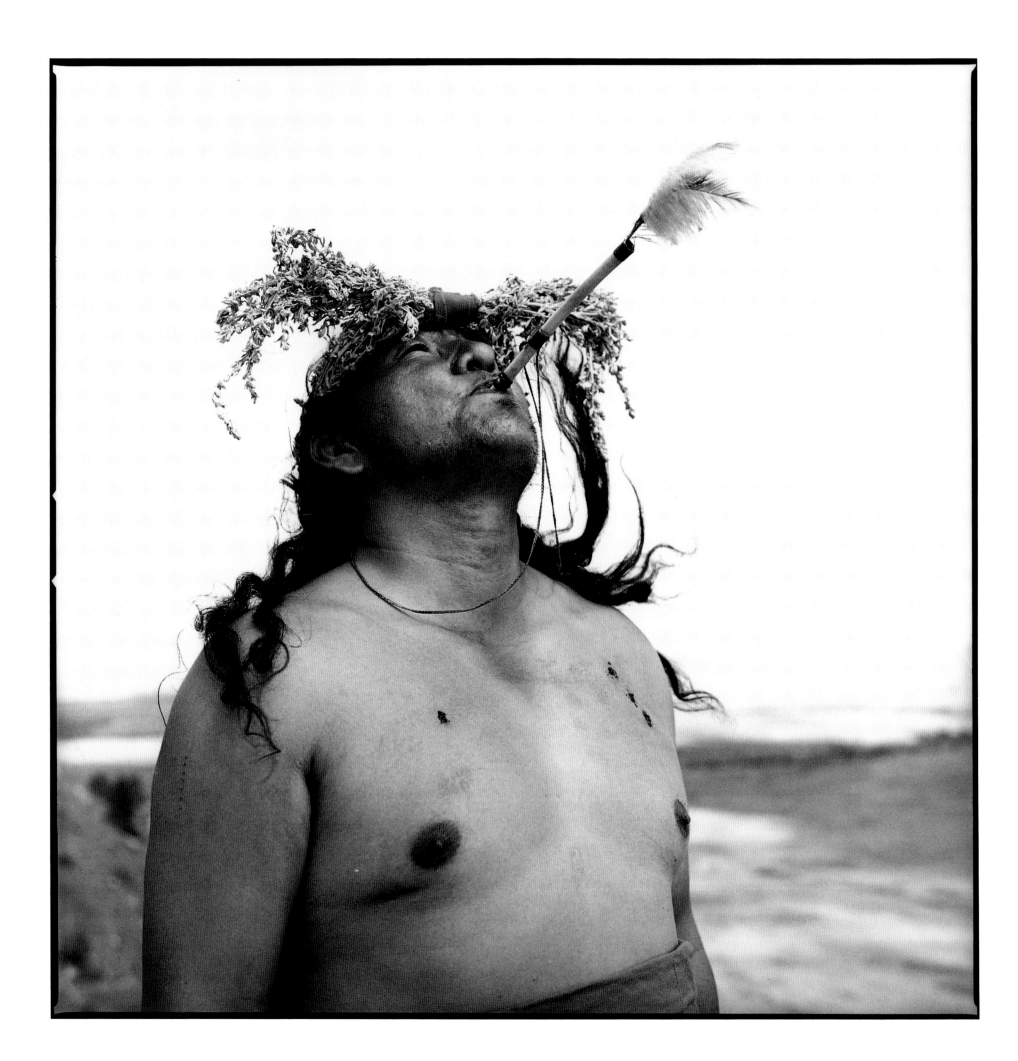

LAKOTA HEALING

A · SOUL · COMES · HOME

PHOTOGRAPHS BY

MARCO RIDOMI

TEXT BY

MARCO RIDOMI
WITH LAURA GACCIONE

STATION HILL / BARRYTOWN, LTD.

Published by Station Hill / Barrytown, Ltd. in Barrytown, NY 12507.
E-mail: publishers@stationhill.org
Online catalogue: http//:www.stationhill.org

Station Hill Arts is a project of The Institute for Publishing Arts, Inc., a not-for-profit, tax-exempt organization in Barrytown, N.Y., which gratefully acknowledges ongoing support for its publishing program from the New York State Council on the Arts.

Photographs of Marco Ridomi on pages 59, 75, 91 are by Mark Pugsley
Photograph of Marco Ridomi on page 92 is by Ron King

Typesetting and design by Susan Quasha

Library of Congress Cataloging-in-Publication Data

Ridomi, Marco.
 Lakota healing : a soul comes home / photos by Marco Ridomi ; text by Laura Gaccione.
 p. cm.
 ISBN 1-886449-66-X (alk. paper)
 1. Teton Indians—Rites and ceremonies. 2. Teton Indians—Religion. 3. Teton philosophy.
 4.Healing—South Dakota.
 I. Gaccione, Laura. II. Title.
 E99.T34R53 1999
 299'.74—dc21 99-11452
 CIP

Contents

Acknowledgments

I would like to thank Atma Levitt, who assisted with the development of the narrative, Laura Gaccione for her collaboration in writing the final draft of my story and Susan Johnson and Susie Kaufman who edited the manuscript. Also, thanks to Michael Johnson who was my production manager and "coach" for the entire project.

I dedicate my photographs and my story to the Lakota people, the Tunkashilas (spirits) and all those who have supported me in my quest for health and spiritual renewal. At a time during this journey when I was filled with love for all that I had received, I asked Godfrey if I could photograph his family. Photography is a medium in which I can express my deeper feelings, and I envisioned a portrait of my Lakota friends in the form of a book. Godfrey gave me permission to do this. I hope these photos convey something of that world I was blessed not only to enter, but to be welcomed into as an extended family member.

You will never be healed of an illness if you focus on each and every detail of your disease's degenerative process. Instead you must find a way to "wipe the windows" of your life—to clear the lens of the soul so that you may see and experience each living moment for what it is—and embrace it with trust and wonder.

MARCO RIDOMI

Introduction

My name is Marco Ridomi and this is the story of the retrieval of my soul. It is hard to know at what point I lost it. I imagine I had it when I was born—in 1952—the child of an Italian diplomat and a literary mother. Like many Italians, I grew up loving culture and the arts; unlike many, I felt no connection to the mysteries or ritual of the Catholic faith.

My father died unexpectedly in my teenage years, and I felt forlorn, as if I had lost an important guide. This sadness followed me like a shadow as I moved to New York City in my twenties to study photography. I eventually became an artistic, commercial and financial success. I loved the excitement of the city and all the opportunities it had to offer me.

As time passed, though, I got involved with the darker side of New York. Despite my successes, I began to suffer from depression. I questioned my worth as a human being, and my reasons for living. I became engaged in self-destructive distractions to keep me from facing an increasing sense of emotional pain and dissatisfaction in my life. I did not want to look into that void.

This feeling was magnified in 1987, when I was diagnosed with a life-threatening illness. It seemed somehow related to my emotional bleakness, and I began to realize that I needed to find answers to my internal condition if I was to survive my external one. I remained fairly healthy, but was anxious to reverse the course of the disease. I needed to regain my will to live.

At first I sought help from a psychotherapist. It was only a beginning. My desire to heal eventually led me on a five-year search to unexpected and unfamiliar places, and to an opening of myself to a life of spirit that I never knew existed. I now see my illness as a doorway: instead of ending my life, it opened me up to a way of being that I could never have imagined.

Getting to Kripalu

In 1991, my New York analyst recommended that I take a hiatus from my work as a photographer. At this time, I was constantly anxious and preoccupied with death, and felt cruelly vulnerable to my illness. It was as if life itself had turned against me. My analyst's suggestion was to go to the Kripalu Center for Yoga and Health in Western Massachusetts for rest and relaxation.

It was with great skepticism and resistance that I set off. I had heard that part of Kripalu's healing philosophy involved spirituality. I still occasionally attended Church on Sunday and holidays, but had never felt moved by the Catholic services or philosophy. I had never practiced meditation and had no idea even how to unwind. What would these people who lived in a contemplative state of Indian philosophy and meditation make of a hard-driving New Yorker like me? What would they expect of me?

When I arrived, I found that it was, in fact, too quiet. Kripalu is located in the peaceful and beautifully pastoral Berkshire mountains. The setting of woods and meadows, with a stunning view of the surrounding mountains had no impact on me: there was no place to get coffee or cigarettes. Despite the staff's encouragement to relax, slow down, and reflect on my life, I left almost immediately. I returned to New York and told my therapist that Kripalu was not for me. He told me to be patient and encouraged me to give it another chance.

I must have been desperate, because I did. On my second visit, I had a major physical and emotional breakthrough.

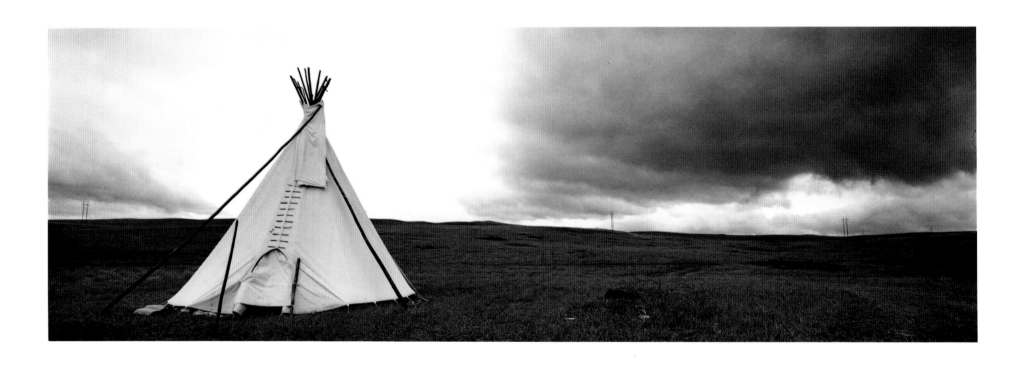

My First Awakening

My tolerance had improved to the point of attending yoga classes. One day I was in a class led by a man named Rup Kumar (Carlos Bulnez). We had finished the physical poses or asanas and my body felt open and relaxed. The yoga had made me stretch my body's limits in a way it hadn't for years. We lay on blankets on the floor, in preparation for the guided meditation which ended every class. Rup Kumar softly spoke:

> "Just allow yourself to lie in a relaxed position. Watch your thoughts as they come and go. Feel the floor beneath you, the sky above you and your connection to the energy of the universe. See how deeply you can relax... Let go."

Suddenly I had the sensation that I was floating. The weight of the pressure of my worries lifted. For the first time in months, I felt good. For the first time in my life, relaxation shifted from being a mental exercise to a real feeling permeating my body. I was comforted and elated.

I had a strong need to communicate this experience. I arranged to meet privately with Rup Kumar and we began a series of conversations which would turn out to be pivotal in my healing journey. He turned out to be a man of discerning awareness, with a listening heart and receptive mind. I told him what had happened to me and the great relief I had found during his class. I opened my heart and shared my struggle with life and illness.

Our friendship blossomed. Rup became my teacher and guide. During our many talks together, we discussed alternatives to aid me in my healing process. His strongest recommendation was for me to seek a healing ceremony with a Native American Lakota healer, Godfrey Chipps, whom he knew personally.

Despite this fulfilling friendship and continuing support, I was still confused and unclear about my life's direction. I wanted to lead a normal life with long and short-term goals, but the uncertainty of my illness kept me from doing this. I regularly returned to Kripalu.

On one auspicious visit, I heard that Godfrey Chipps had traveled from his home in South Dakota to Becket, Massachusetts, just a couple of towns away.

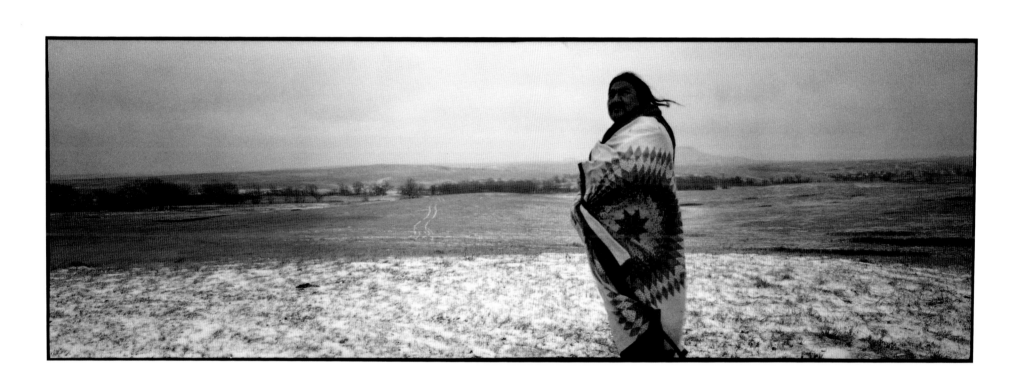

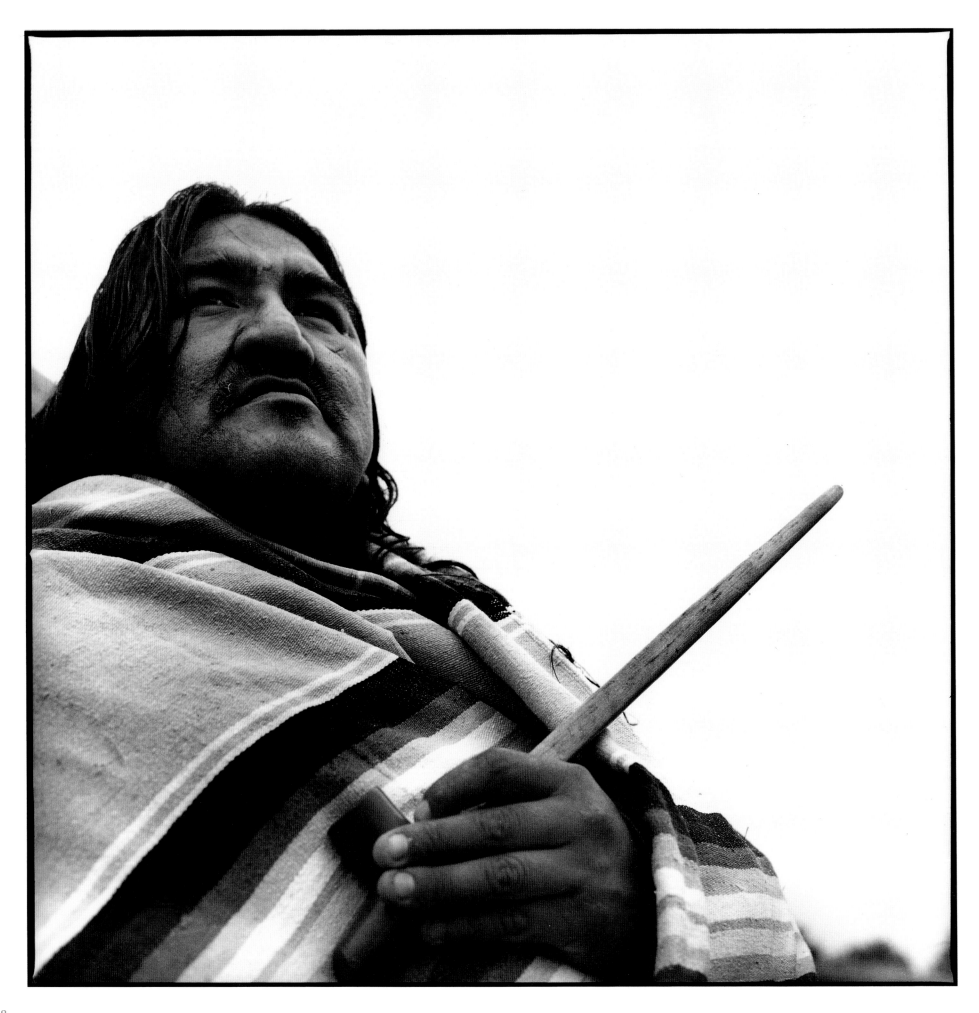

Medicine Man

Becket is a small town full of beautiful mountain scenery and lakes. It is the site of the nationally known Jacob's Pillow Dance Festival, and the Kushi Institute of Macrobiotic healing. Creative and healing energies seem to thrive there. I found the place I had been told Godfrey was staying: a small house at the end of a dirt road. I went to the door and asked to see him, and was directed to a small field nearby.

In the clearing, I came upon a dome-shaped structure made from bent saplings that were secured with strips of colored cloth and covered with blankets and a tarp. Several men with shovels and long poles were tending a fire in a deep pit. I didn't realize that an inipi, or sweat-lodge ceremony was scheduled for that day. The people who directed me must have thought I was there to participate in the ceremony.

I was told to undress and enter the lodge. I watched as the hot stones from the fire were brought in and placed in a wide hole. I went along with it, though I really had no idea what was happening. As the stones were placed, some of the men chanted songs and a drummer kept a powerful and rhythmic beat. I was moved by the strength and passion of the singers, though I didn't understand a word. I watched in amazement and then concern as the canvas flap that served as a door was closed and we were plunged into darkness. The rocks threw off an enormous amount of heat and illuminated the interior of the lodge with an eerie red glow.

After only a minute or so, it became unbearable for me. I began to panic, and asked to leave. Fortunately, the door was opened for me and I crawled out of the lodge.

I quickly put on my clothes and began to wander around the property. Though I was afraid that I was missing an important opportunity for my healing, I couldn't deny my fears. The sweat lodge was too intense for me. I finally returned to the house and there was able to meet Godfrey.

I was initially taken aback by his appearance. He looked more like a biker than a healer or spiritual guide. He had long, dark hair, and was dressed in a black leather jacket. He, too, smoked cigarettes.

My desperation must have been stronger than my apprehension, because when I finally addressed him, I did my best to convince him to do a healing ceremony for me in Becket. "Your problem is too big," he said. "You must come to South Dakota." My pleas about the length of the journey fell on deaf ears, as he consistently repeated that phrase. "You must come to South Dakota." Chipps felt that I would have the best chance for healing in the place that was his home—a land empowered by its own, special, indigenous healing spirits. There was no other choice.

IN MY GENERATION
I WAS HONORED, LOVED,
AND RESPECTED, AND
NOW I AM NO MORE

REMEMBER ME THROUGH
MY ACCOMPLISHMENTS
THE CHANUPA, THE MEDICINE,
MY BOYS

REMEMBER ME FOR THE
THINGS THAT I TEACH
FOR I AM NOW PART OF THE
LAND AND THE SPIRIT

(text on the tombstone of Godfrey's father Ellis
in facing photograph)

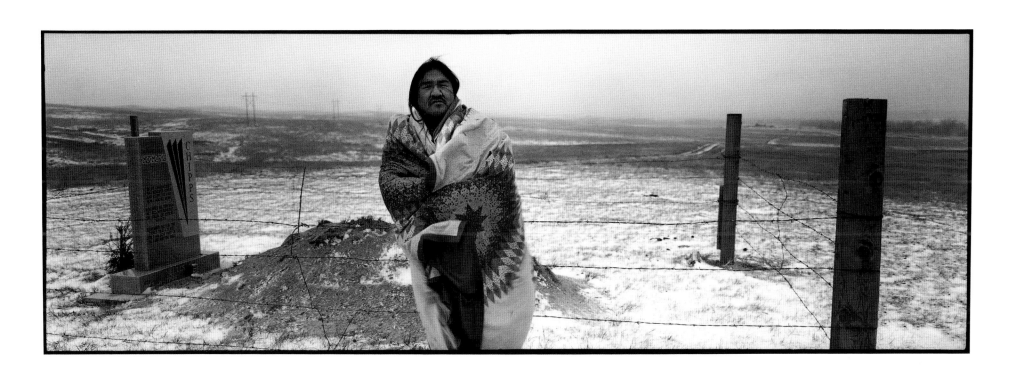

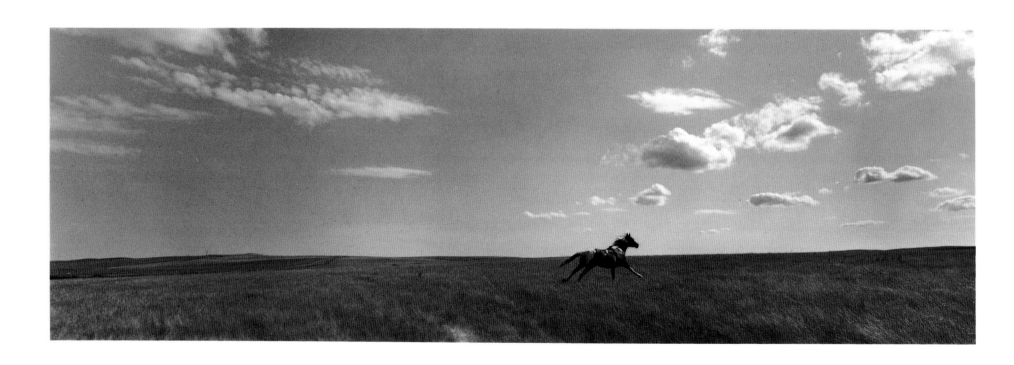

Pine Ridge Reservation

In June of 1992 I was on a plane to South Dakota. Driving from the airport to the reservation in my rental car, I settled into watching the scenery of endless grassy plains. I traveled for miles without seeing cars or houses. There was not even a buffalo in sight. Only the waving grass revealed the mysterious presence of the wind.

Several hours into the journey, I felt a subtle presence sitting next to me in the car. Turning, I saw an old Indian figure, with a wry smile and a soft light in his eye. He spoke to me, saying, "Welcome to my land." And then he was gone, as quickly as he came. He was a fleeting apparition, gone in seconds. I was startled by his presence. Remember, I'm just an "old time" Italian guy from Florence with no taste for the mystical. I knew nothing about the Lakota Nation or Native Americans in general. This world was beyond my understanding.

But after I calmed down, I found that I was comforted by his appearance. I was pleased to have such a mysterious traveling companion. His words, "Welcome to my land," were warm and sympathetic, and gave me hope. I felt that he was a messenger sent from the spirit realm to usher me into his land of ancient wisdom.

I arrived at the Pine Ridge Reservation and pitched my tent on Chipps family property outside the village of Wamblee. It is called "the Country" by the locals. The site is one of beautiful desolation—miles of prairie bordered by rolling hills and set off by Eagle Nest butte about a mile or so away. It contains the century-old simple house where healings are performed. There were also two trailers there, where family members stay during healings. In anticipation of a month or so of roughing it I settled in.

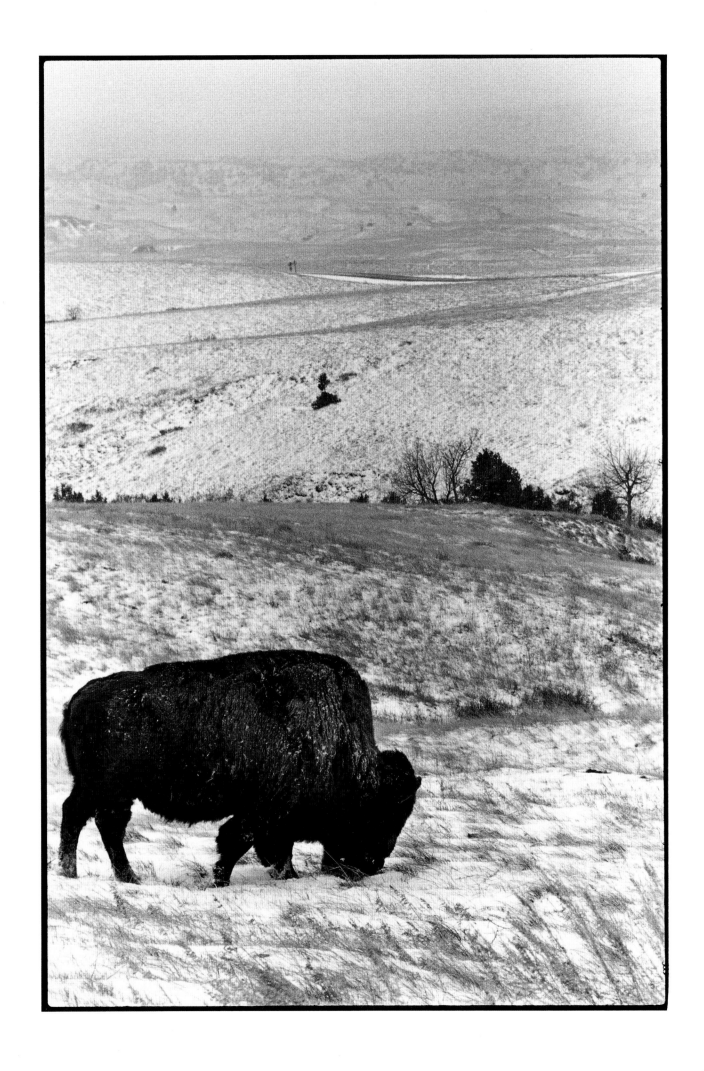

My relationship with Godfrey and the rest of his family began. I met Grandma or "Unci" Victoria, Godfrey's brothers, and Sal, the apprentice from Northampton, Mass. who had moved onto the reservation to learn the ceremonies and was now Godfrey's son-in-law. I met his 13 children, who are cherished by the tribe. I was to learn and appreciate much more about these tribal descendants of Crazy Horse, but was fixated, at the time, on my impending ceremony with Godfrey.

At first I was impatient with him. I couldn't keep track of his whereabouts. I woke up in the morning and he would be gone unexpectedly and then three days later he would suddenly come back. I thought to myself, "When are we going to get on with this?" There seemed to be no plan or organization to guarantee that it would happen. Was this a hoax? Was it "real?"

No one had prepared me for the culture shock of the harsh life of the reservation. Many people abused alcohol to escape. My feeling of desperation and loneliness became stronger. Surrounded by the desolate landscape, generations of poverty and a quiet that comes from endless prairie, I wondered once again what I was doing there.

Days passed. I began to loose my sense of time. The only point of reference I had for the passing of hours became my periodic sensation of hunger.

Finally, I began to get some directions for my ceremony preparations.

Godfrey's mother, Unci or "Grandma," was my mentor. She showed me the proper way to prepare. Unci is the matriarch of Godfrey's family and a keeper of the traditional Lakota spiritual ways. She is strong and vital enough to help raise her grandchildren. Her spiritual life is very important to her and she is always up at dawn to pray. Unci gave me detailed instructions on how to carefully prepare meat, bread, dessert and coffee for the sacred meal that would be eaten after my healing ceremony. In addition, she instructed me in how to make prayer ties and other offerings that were needed for the ceremony.

Prayer ties are small bundles of tobacco, wrapped in small colored squares of cloth. I had to assemble four hundred and five of these, and then tie them on a long piece of string. Even if a person was very sick, even if they couldn't walk, Grandma always insisted that they do their own prayer ties in preparation for their healing ceremony. As I made each little bundle and knotted it on the string, I found myself conversing with the spirit world through my prayers, asking for help, talking to the unseen forces surrounding me. Without forcing it, or even knowing why, I began to reflect deeply on what was truly important in my life.

"Don't loose your focus," Grandma instructed me. Prayer became my focus and Grandma became my primary guide and teacher in this ancient tradition. She explained to me that Godfrey's role was to invoke and communicate with the spirits, the Tunkashilas, in the ceremonies. I felt comforted by her spiritual discipline.

The time when my healing ceremony was to happen was still not clearly scheduled. I was informed that we were on "Indian time": things and events happen when the time is "right," and not by a predetermined agenda. Grandma told me that Godfrey would come to do my ceremony at a time of his own choosing. There was no way to predict when he would be ready physically, psychically and spiritually.

The Tunkashilas, powerful spirits that he summons, demand that the ceremonies be done very precisely and respectfully. The ceremonies are very challenging. Grandma told me that Godfrey must make sure that everything is done correctly and that the participants are focused and praying. I began to accept the strangeness of all this but I was still impatient for my ceremony to be underway. I had been preparing constantly for days. Godfrey finally declared that my healing ceremony, known as a Yuwipi, would happen that evening.

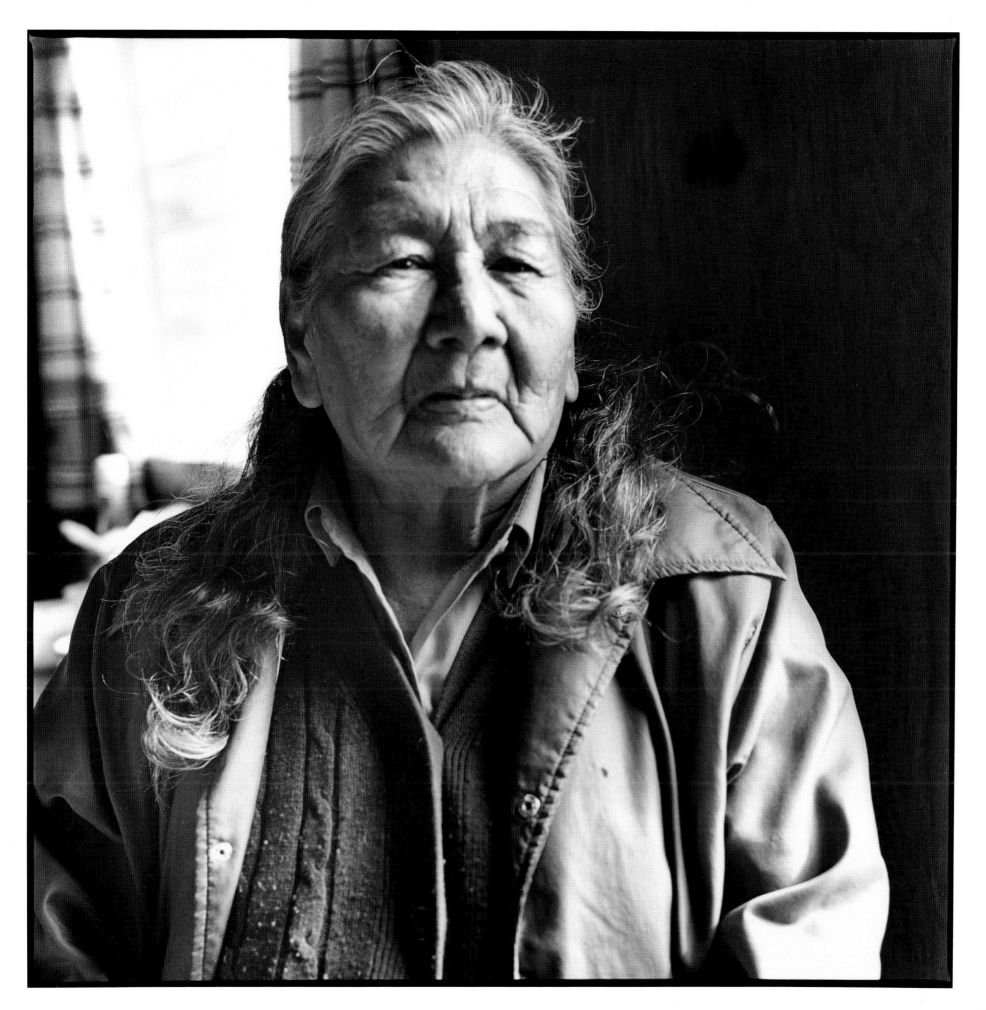

YUWIPI (Spirit Calling Ceremony)

We gathered around midnight in the small, unfurnished 20' by 20' ceremony room. A single kerosene lamp was burning and the windows were covered with black plastic. It was hot. I had been told to sit on the north side of the room behind the wooden altar. Grandma was there to hold the sacred pipe and to help guide the ceremony. Drummers and singers sat silently as several other people filed in—men to the left, women to the right.

Gourd rattles, eagle bone whistles and other sacred objects and offerings were precisely arranged on the single wooden board that served as an altar on the north side of the room. These were the vehicles by which the spirits would communicate when they were summoned by Godfrey. The sacred meal was laid out, to be consumed later.

In front of the altar a bed of wild sage was strewn. Godfrey stood at the foot of this sacred herb, his hands tied behind his back with a leather thong. His entire body was wrapped in a traditional star quilt that was also secured by another, longer thong. Slowly and carefully he was lowered by several men so that he was lying face down in the sage.

I was touched by the prone and wrapped figure lying so close to me. I sensed that Godfrey was entering into a state of humble surrender in order to communicate with the Tunkashilas.

A large rectangle, created by my four hundred and five prayer ties on their long string, formed a border around Godfrey and the altar. I had been told that this border formed a very important and sacred boundary and that no one was allowed cross over its perimeter.

Like a rebellious adolescent, I felt a need to test the strictness of this rule. Despite days of preparation and the consistent descriptions and explanation of Grandma and Godfrey about their spirit helpers, I doubted the reality of the Tunkashilas and their rules. Slowly, I inched my hand

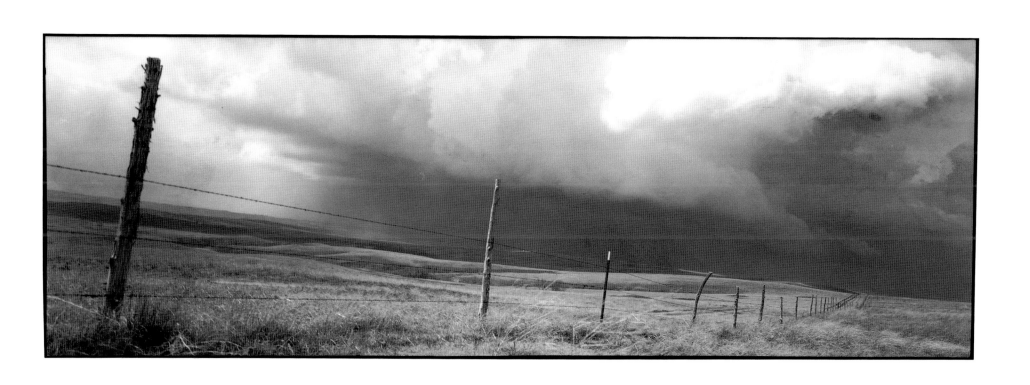

over the side of the rectangle. At that same moment, a rattle from the altar moved, and hit me sharply over the head. The powerful Tunkashilas were already present and active in this completely dark room and they were aware of everybody and everything. I was astonished and humbled.

The room filled with the sound of drums and ancient Lakota sacred songs. I couldn't see the singers, but the pulse of their voices and instruments was very strong. Their voices were low and soothing. I felt the presence of spirit. Animated by them, sparks darted about the room, rattles flew and clattered in the blackness and eagle bone whistles screeched. There were many other strange noises. At one point it sounded like a cow or horse was kicking the door.

I tried not to be distracted by the alarming noises and lights of the Spirits. I was sweating. I remembered that the spirit of the great warrior Crazy Horse was said to enter the ceremonies. Was it he who pounded at the door? My worry was interrupted by the sound of Godfrey's voice.

"It's time for you to stand up." Godfrey's voice came out of the blackness. "Raise one had over your head." As I did, I felt as if I were stretched out very high, as if I had reached into another dimension. "Offer your prayers," ordered Godfrey. The prayers flowed out of me effortlessly after so many hours and days of praying in a focused manner. I asked for the total healing of my illness, for my vital energy to be restored, for my will to live to return. Guided by the spirits, rattles suddenly hit me on the heart, chest and genitals. Grandma said the rattles were "doctoring" me in the places I needed healing. They knew where to go. This went on for several minutes.

"Sit down." The order came out of nowhere. The singing, drumming and other noises suddenly stopped. The lamp was quickly lit and I could see. In the dim light, Godfrey sat barechested on the bed of sage, looking completely spent. A chill ran down my spine as I realized that his hands were free and the blanket that had been secured around him at the beginning of the ceremony was on

the floor. I remembered that Grandma had told me that the spirits would untie Godfrey at the end of the ceremony.

We ate the sacred meal of bread, coffee, meat and dessert, and, the ceremony concluded, I walked out into the cool night air. The sky was exquisite. I had never seen the stars so lucid and palpable, as if I could reach out and hold them in my hands. I felt completely enveloped in the stellar serenity of the night sky. Deeply moved, I later fell into a peaceful and dreamless sleep.

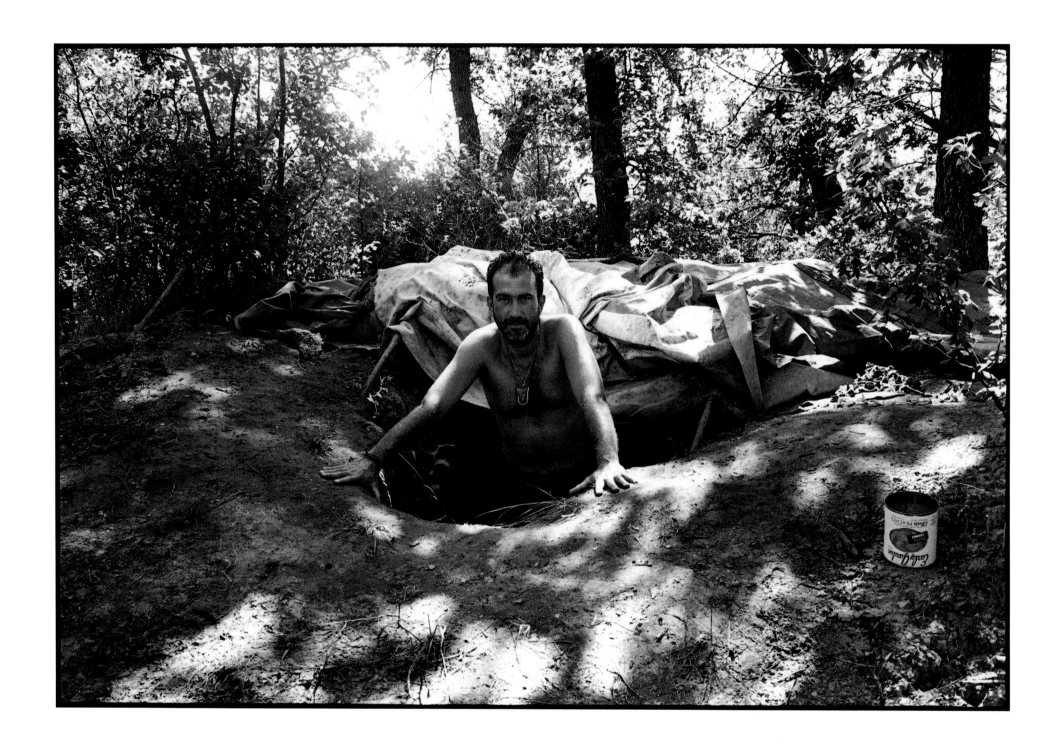

HAMBLECHEYA (Vision Quest)

Godfrey told me after three more nights of ceremonies that I wouldn't have to worry about my illness any more. "You're going to marry and have kids! You'll live to walk with a cane," he said with a smile, predicting a long life. But my healing was not complete.

The spirits had prescribed a "vision quest," the Lakota tradition of enforced solitude and prayer. The purpose is to experience a connection to Spirit that will be sustained through activities of daily life. It involved sitting alone in an eight-foot deep hole in the ground and waiting for a vision. Was I up to this new challenge?

I viewed the pit with concern— eight-feet deep and six feet wide.

After a series of purification rituals, including a sweat lodge (which I finally endured), I was brought to the site. I was helped by others onto the sweet smelling sage that had been spread at the base of the pit. I sat naked, covered by a blanket, holding a prayer pipe (canupa). Two men covered the pit with the curved sapling and canvas roof that blocked out all light. I was left over-night, with no food or water, in total darkness.

I felt inexpressibly alone, desolate and abandoned—the same feelings I had had in New York. Godfrey had told me that a vision would come to me when there were no distractions and when there was only a fierce desire to see, know and receive wisdom from the spirit world. My intention was to sit with a humble attitude and to stay awake so that I could be fully conscious and welcome my vision when it came.

In the darkness, the world seemed to have no beginning and no end. I began to feel my usual defenses drop away. I found that I could pray. And my vision did come, not in an instant, but in

breakthroughs of intuition and knowledge throughout the night, that, woven together, formed a tapestry of hope for my new life.

My "vision" was not visual; it was not a picture. It was a deep awareness that rearranged my beliefs. I simply, finally, knew that God exists. In the vision pit, God shifted from a mental concept to a real Presence. He was unseen, yet permeated my heart and all other aspects of my being.

The lines of Communication had been opened: I realized that I could reach God through prayer and through the gratitude I experience for all that I have. Despite my Catholic upbringing, I had had no previous experience of such a strong spiritual connection. I was filled with reassurance. I felt strength and peace.

I took this vision back to New York with me, where I was energized and excited to meet each day. I began to experience the sacred hoop of life, a revered symbol of many Native Americans. I saw how clearly all aspects of my life were interconnected; how they in fact supported, influenced, and flowed into each other. Every day, I thanked God for being alive. I was more conscious about my healing process. I had more self-control, more courage and more inspiration to go on. Instead of waiting to die, I looked forward to living.

These were remarkable changes in my life and I felt deeply grateful to Godfrey for his assistance. I traveled back to South Dakota several times after my healing ceremonies to see him.

On one visit, he became very emotional and began crying. "I can't heal anymore. I have too many pressures. I have to care for my family and raise my children." Having met his wife, extended family and many of his thirteen children, my heart went out to him. In an instant I saw the painful contradiction between the sacrifices he made for others and his own struggles to feed and clothe his family.

I am grateful to the Chipps family for restoring this old-time Italian guy to his rightful relationship with the Creator, who is the same Presence that permeates the world in all faiths and is the source of all life and peace. I am honored that they allowed me to photograph them. Amen. Aho.

I am like a rock.

I saw life and death—

the worry, the pain, the joy, the happiness.

I am part of our mother, the earth.

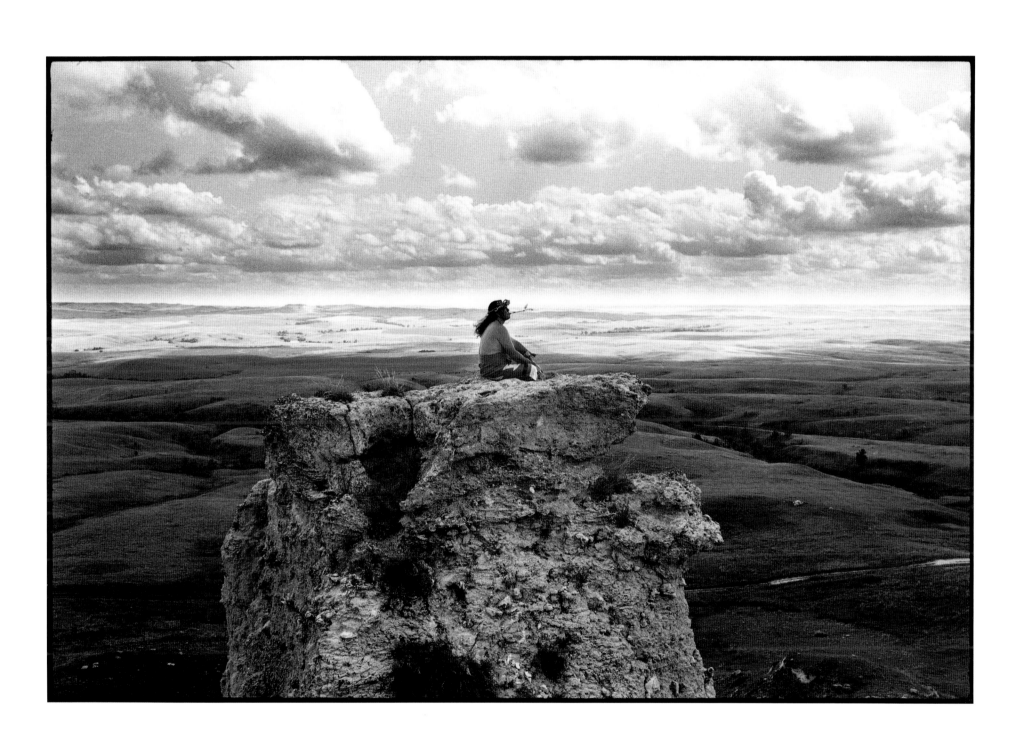

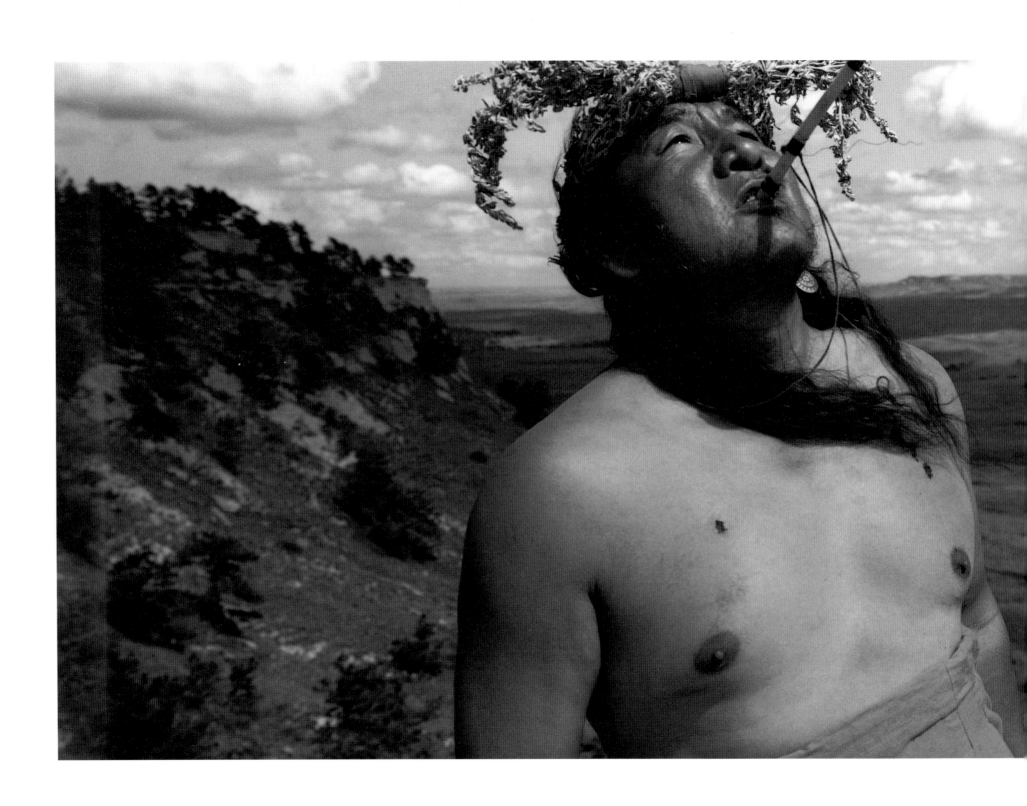

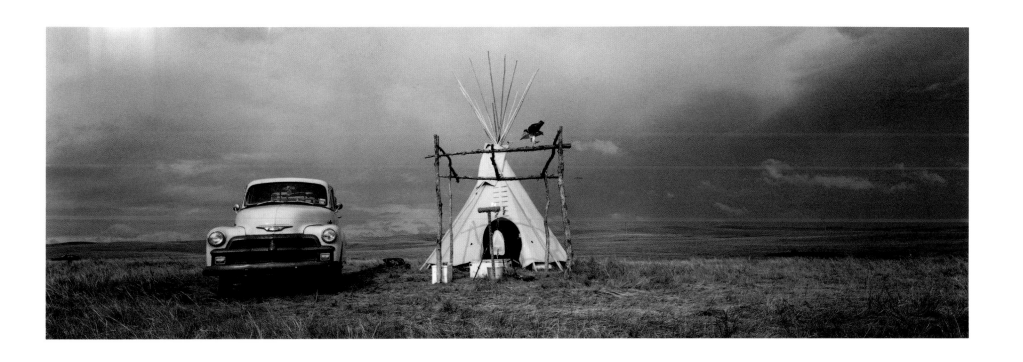

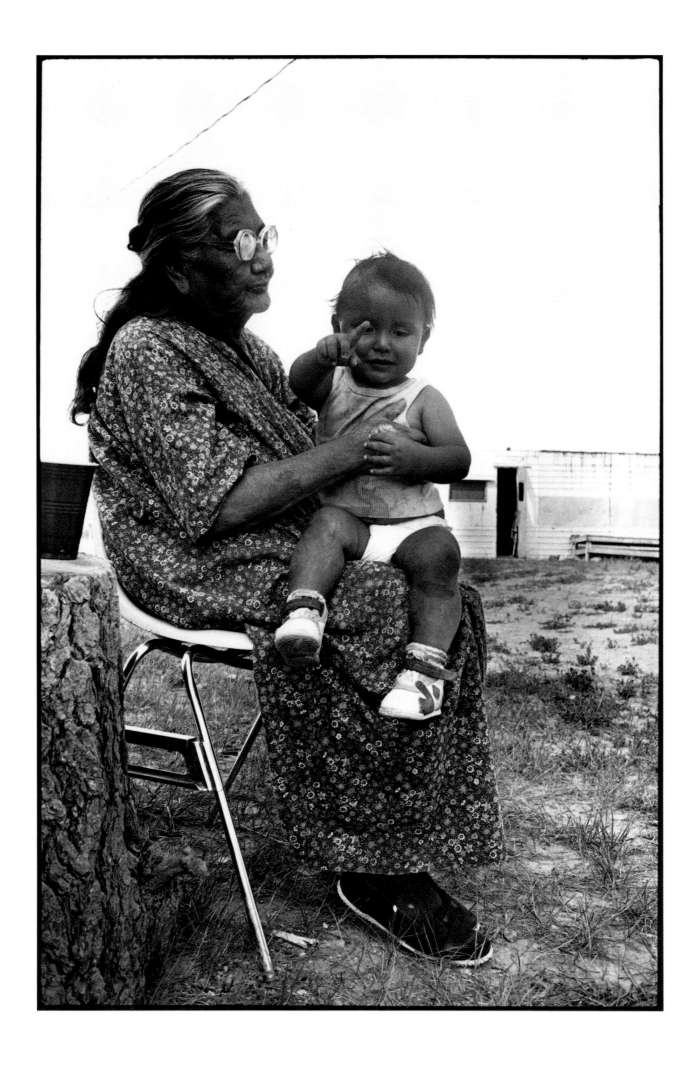

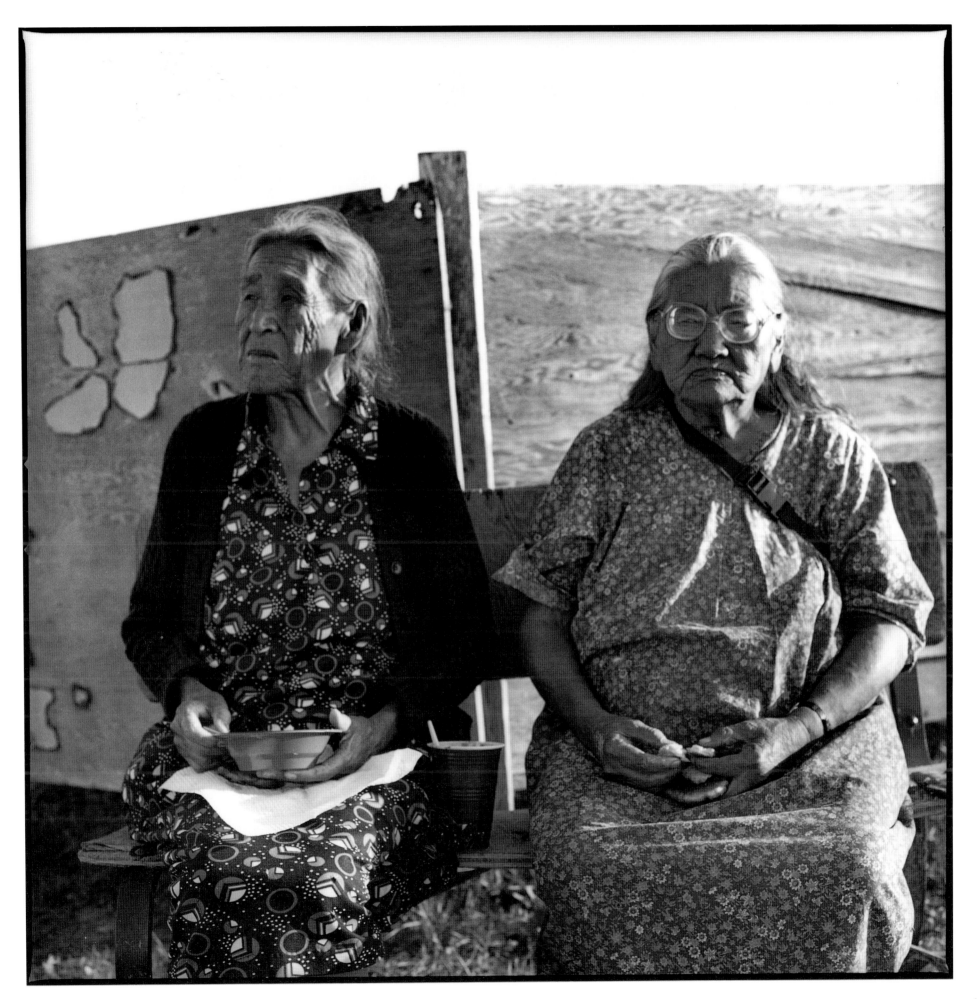

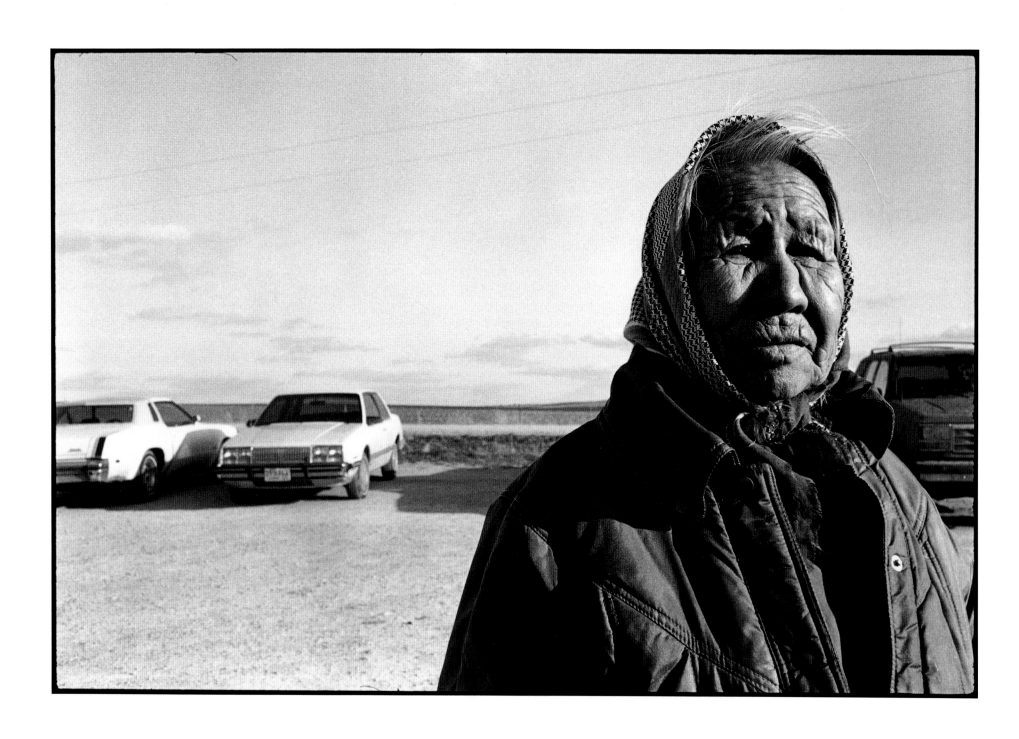

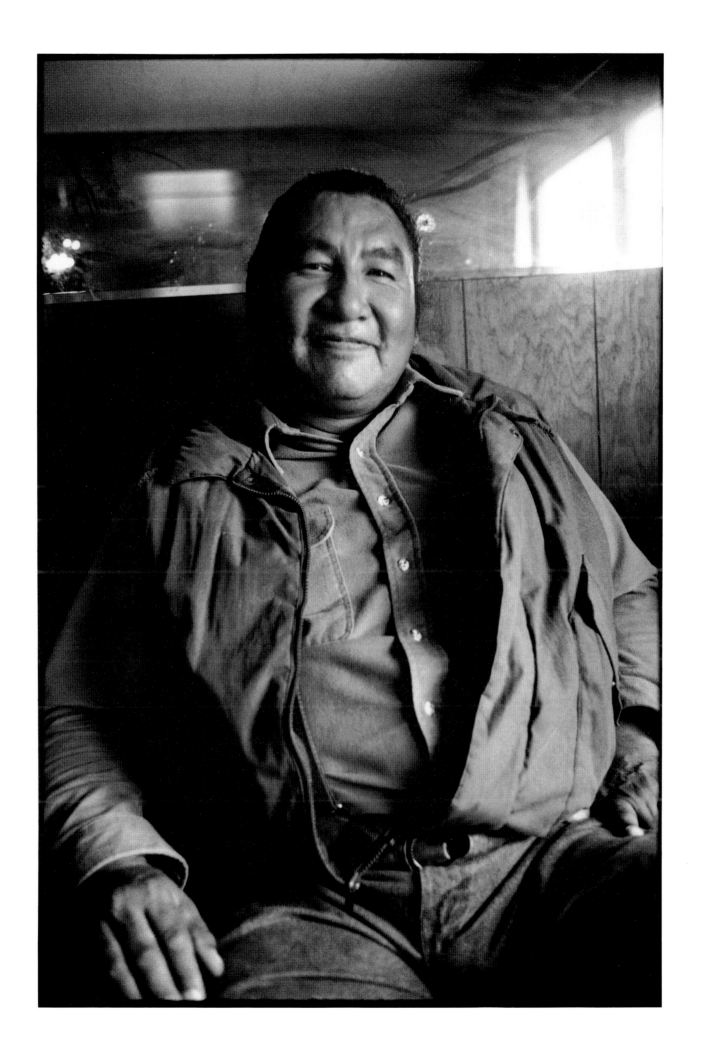

Go around a mountain slowly
because the mountain is silent.

LAKOTA SAYING

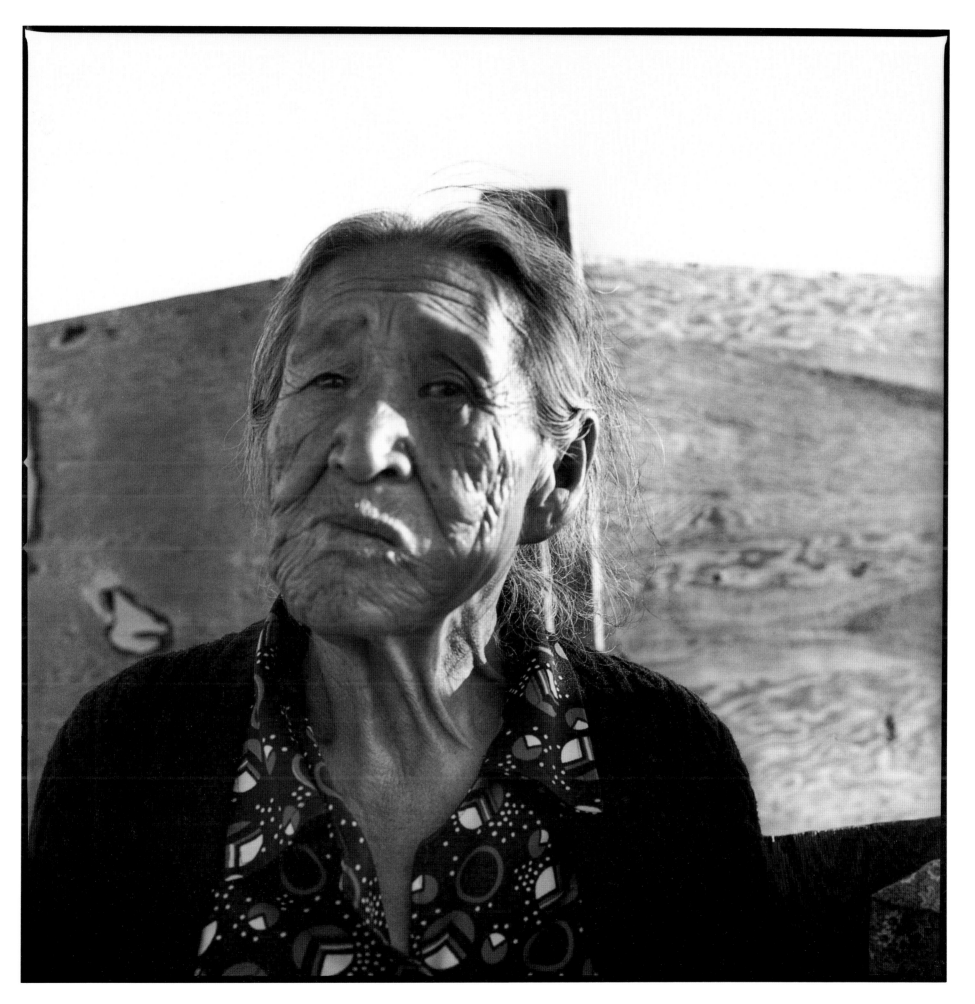

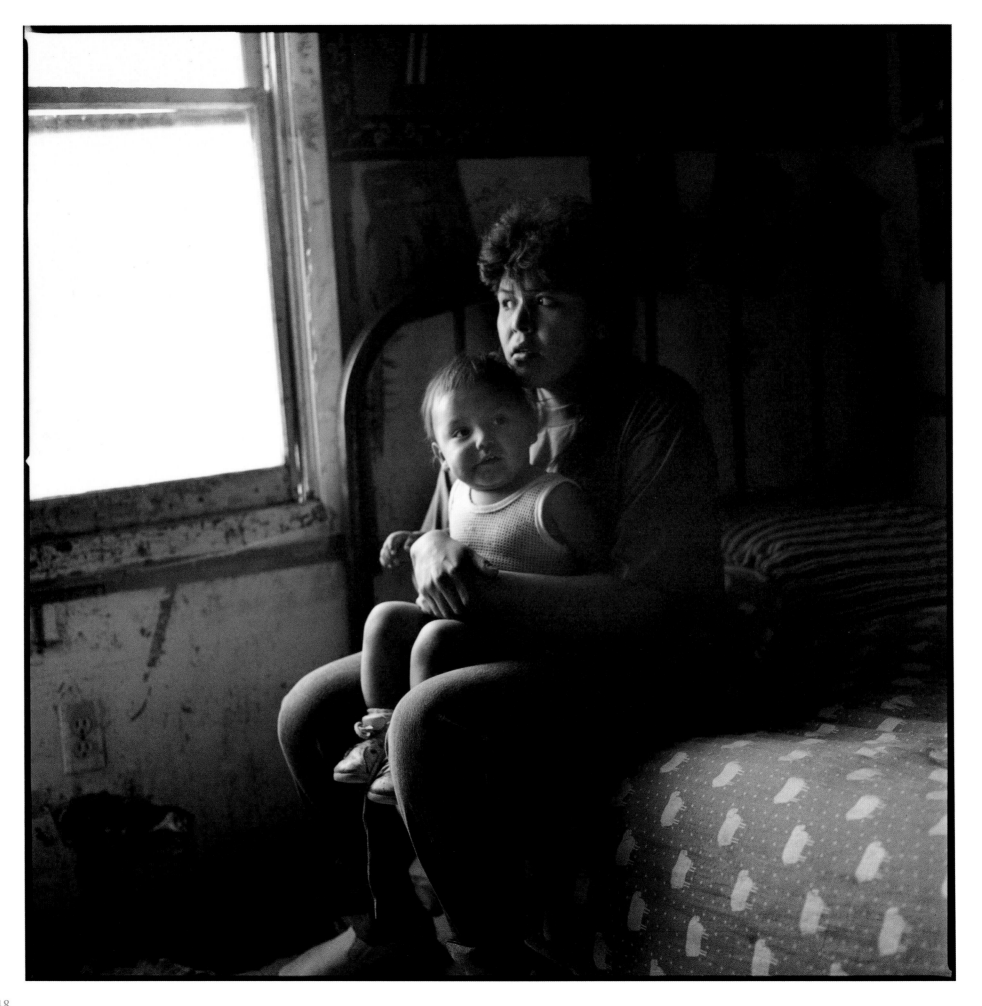

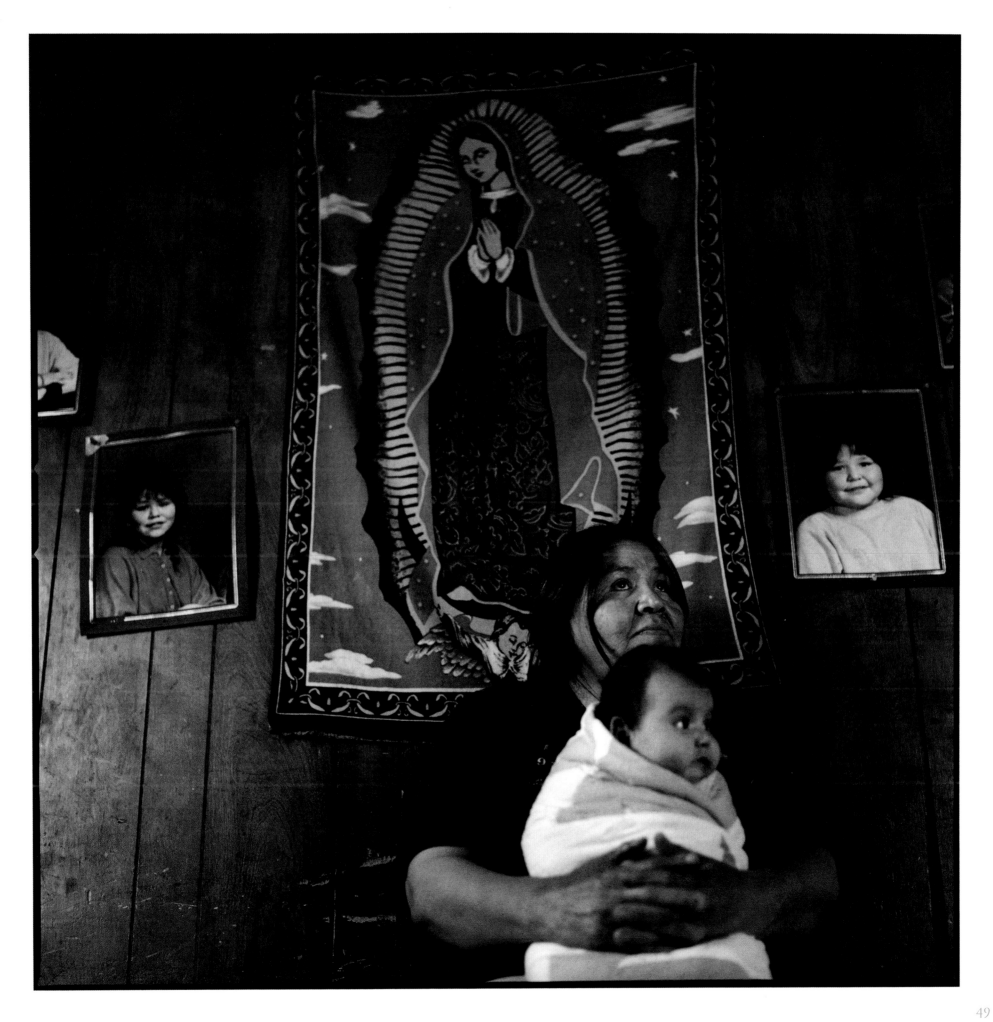

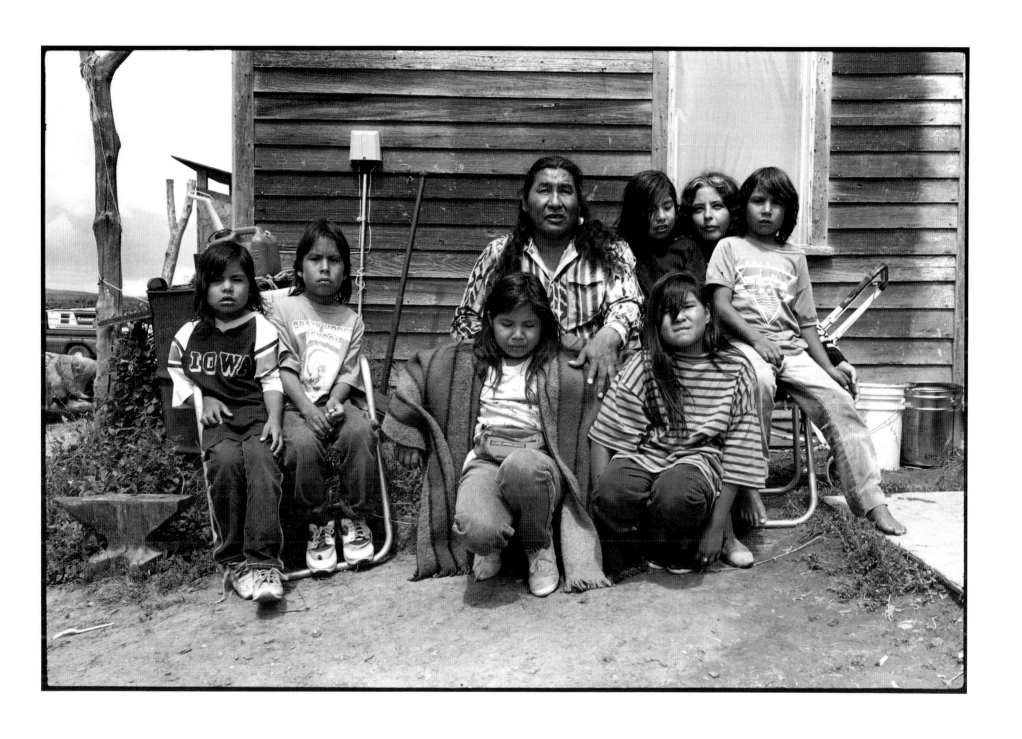

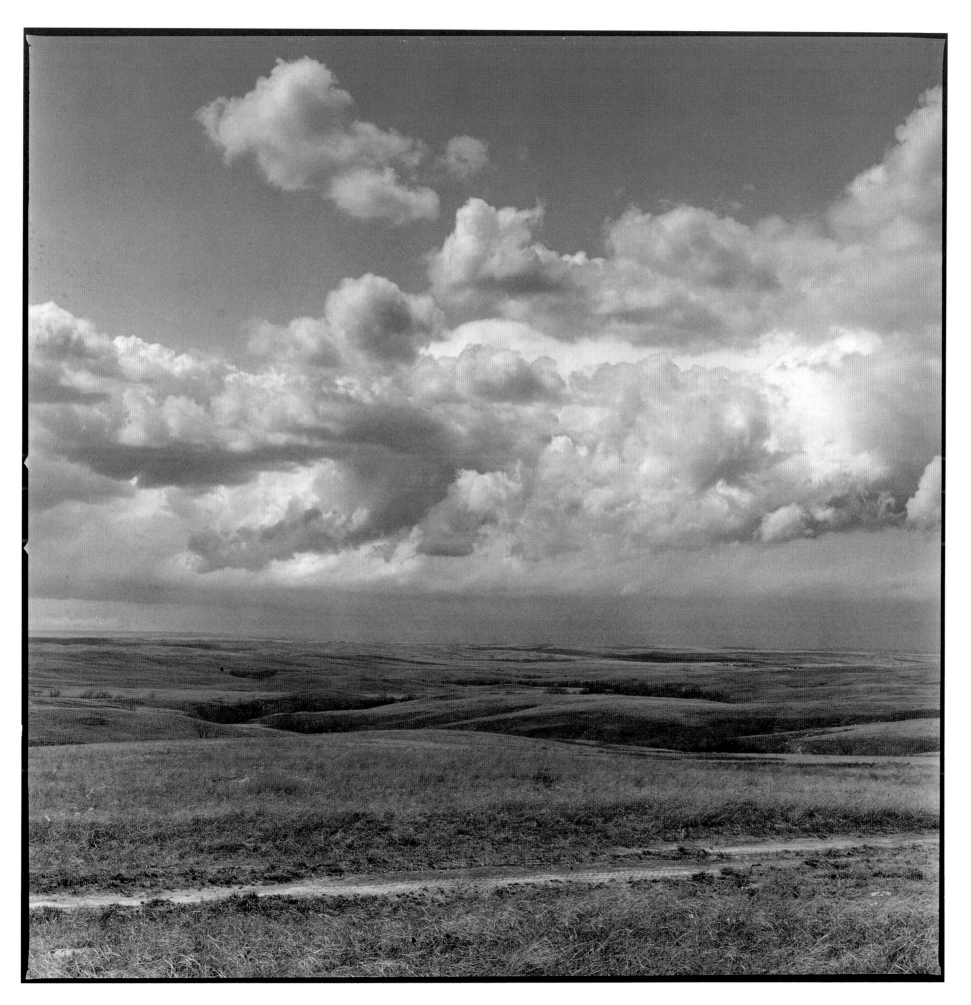

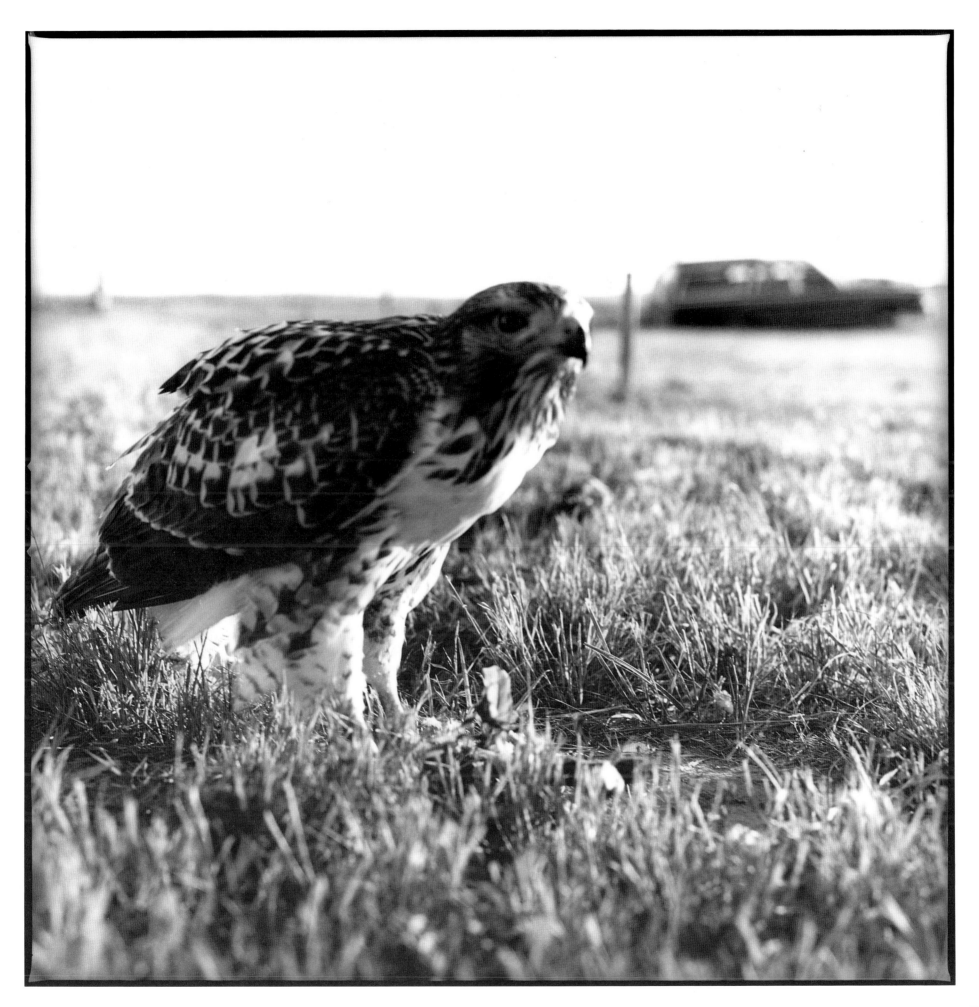

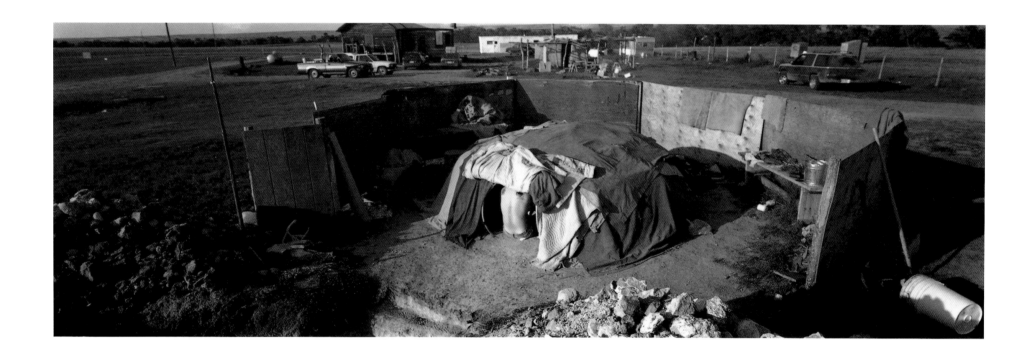

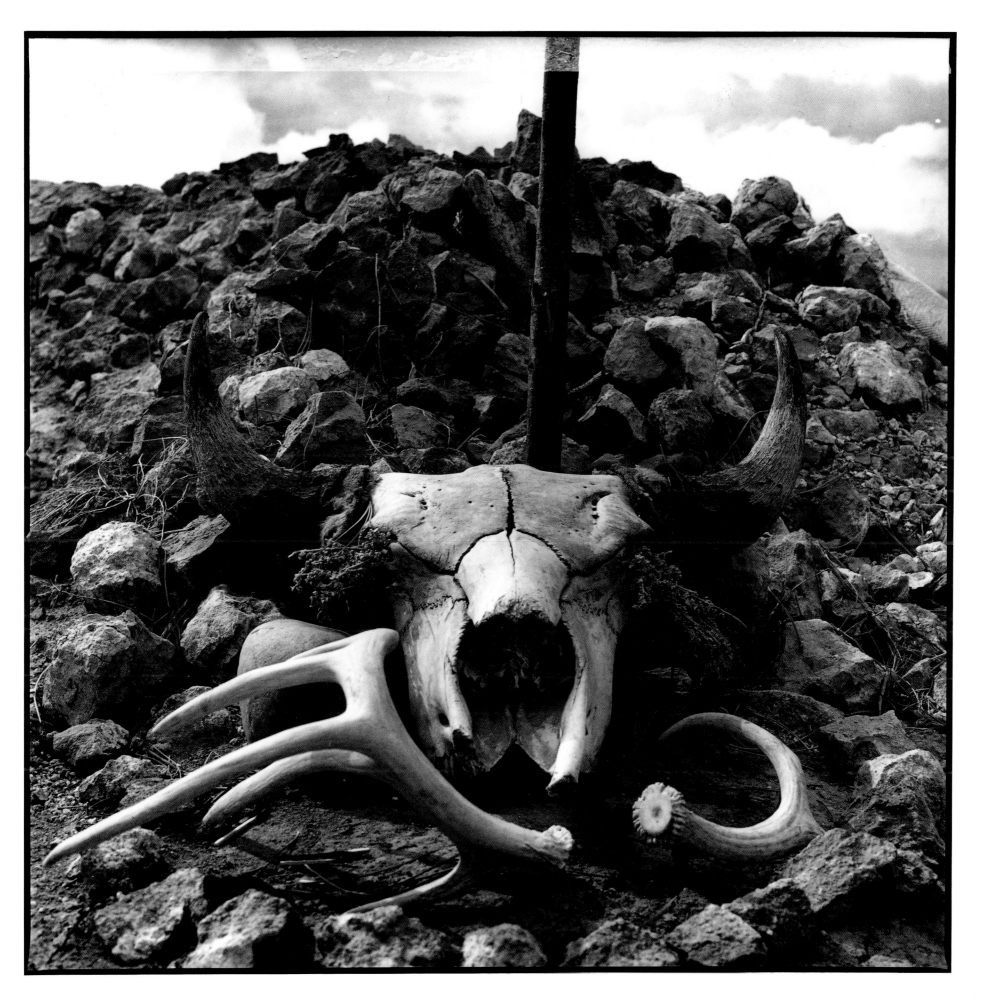

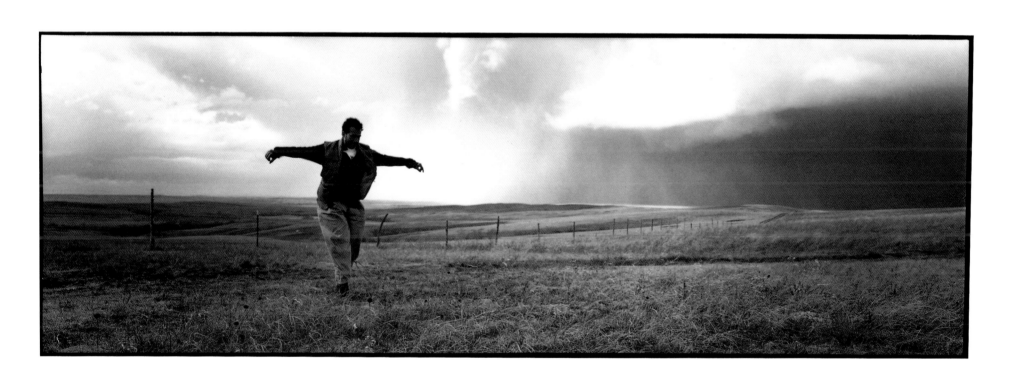

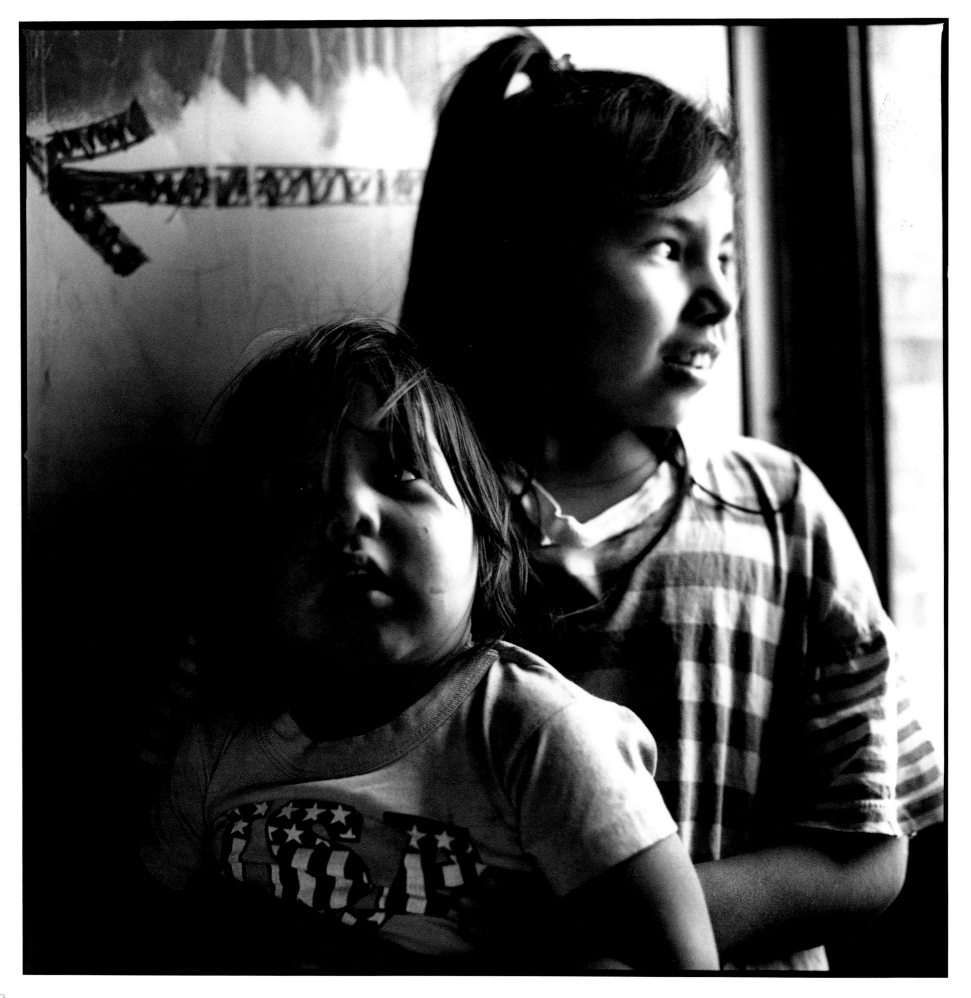

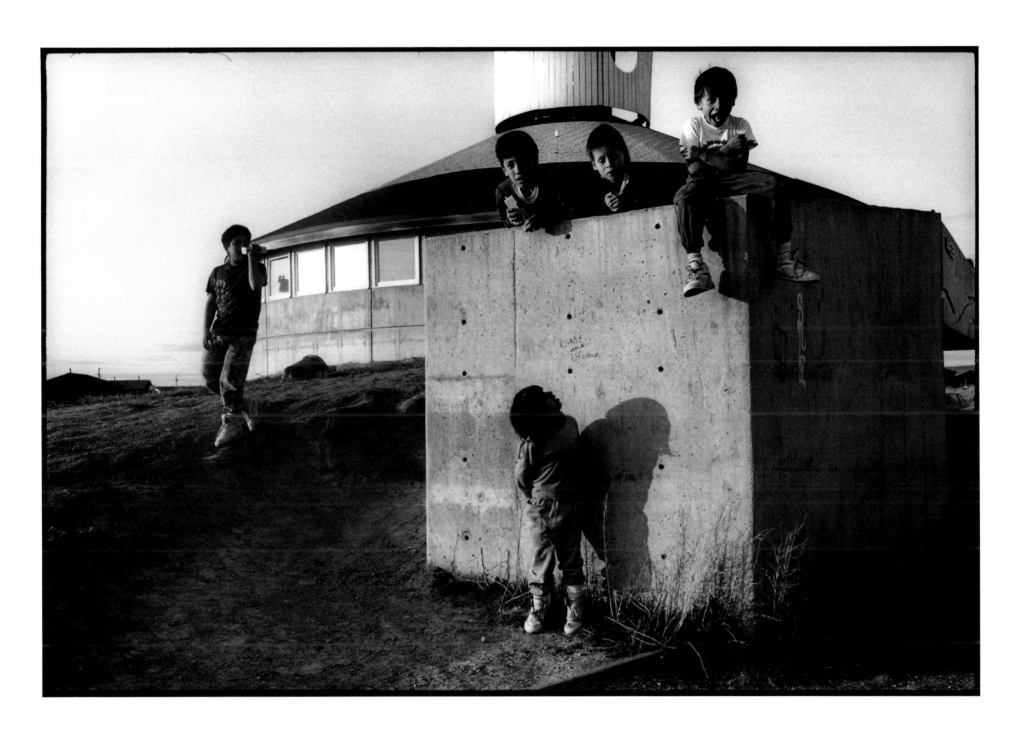

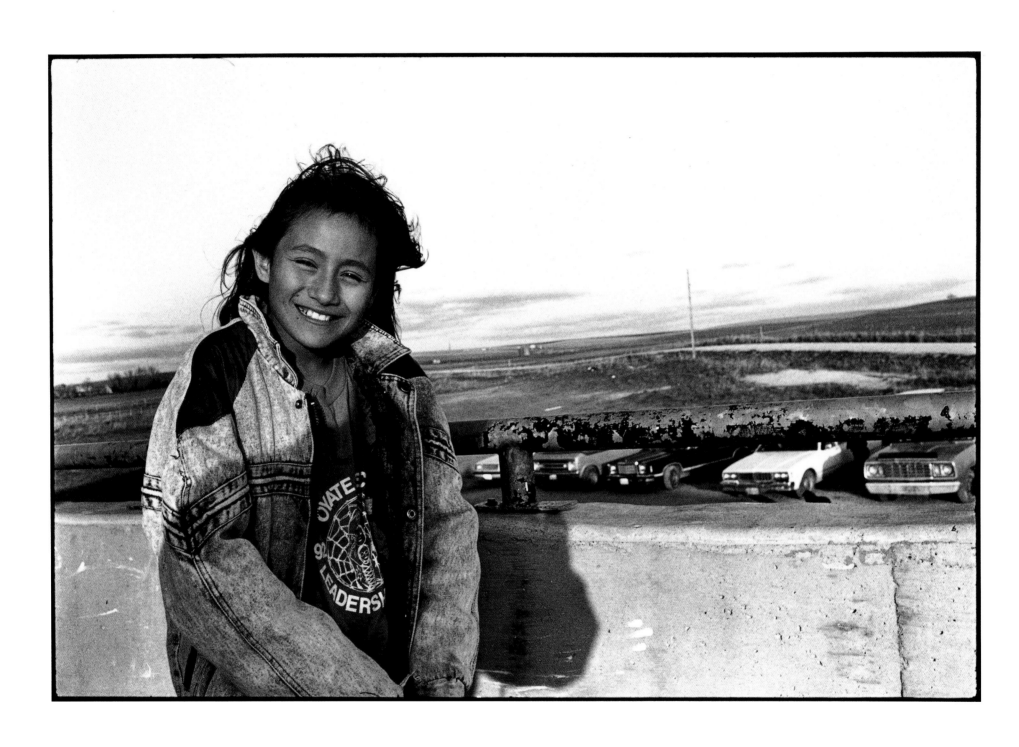

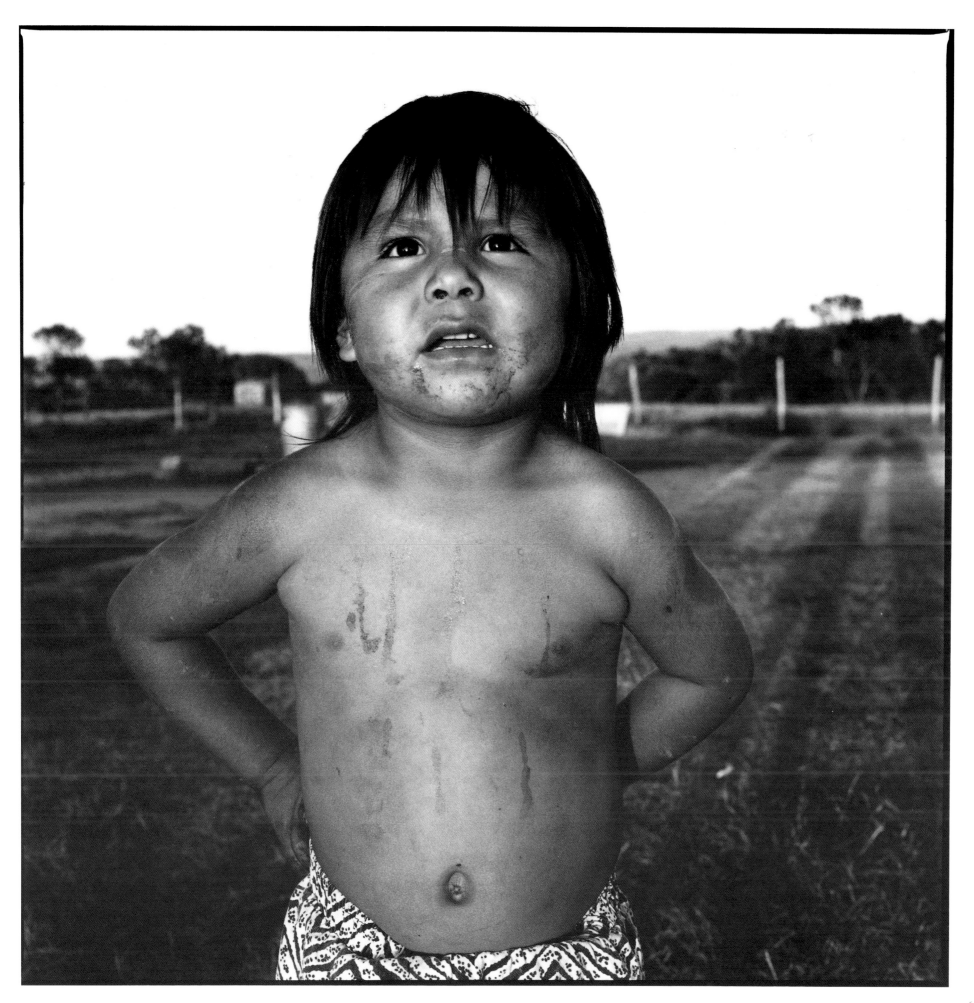

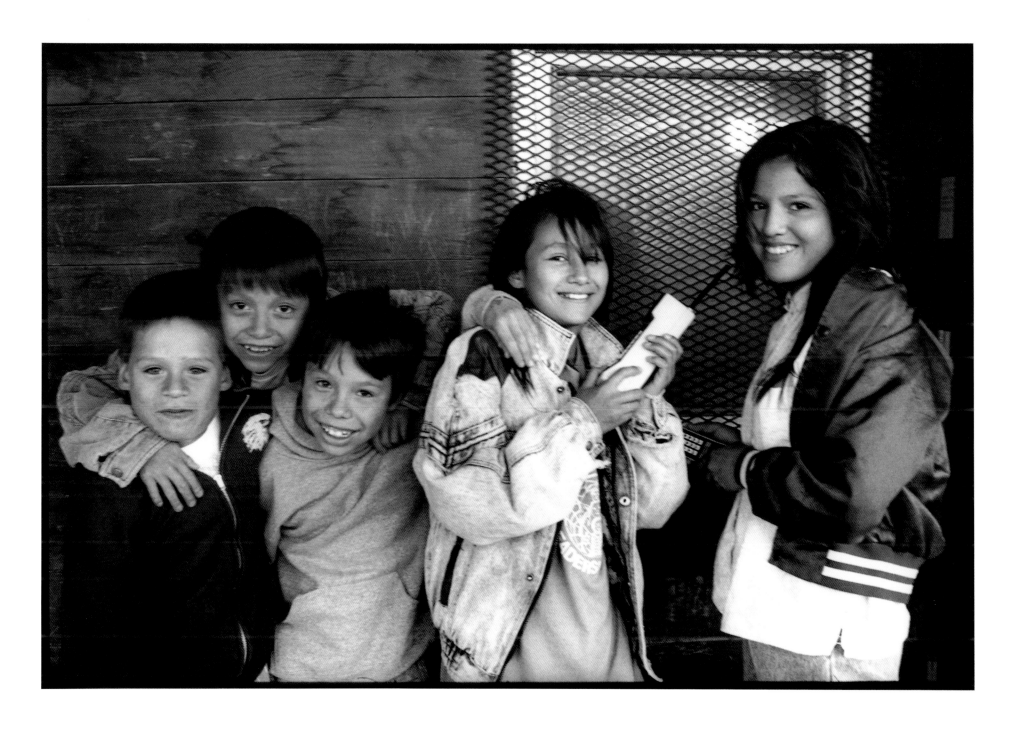

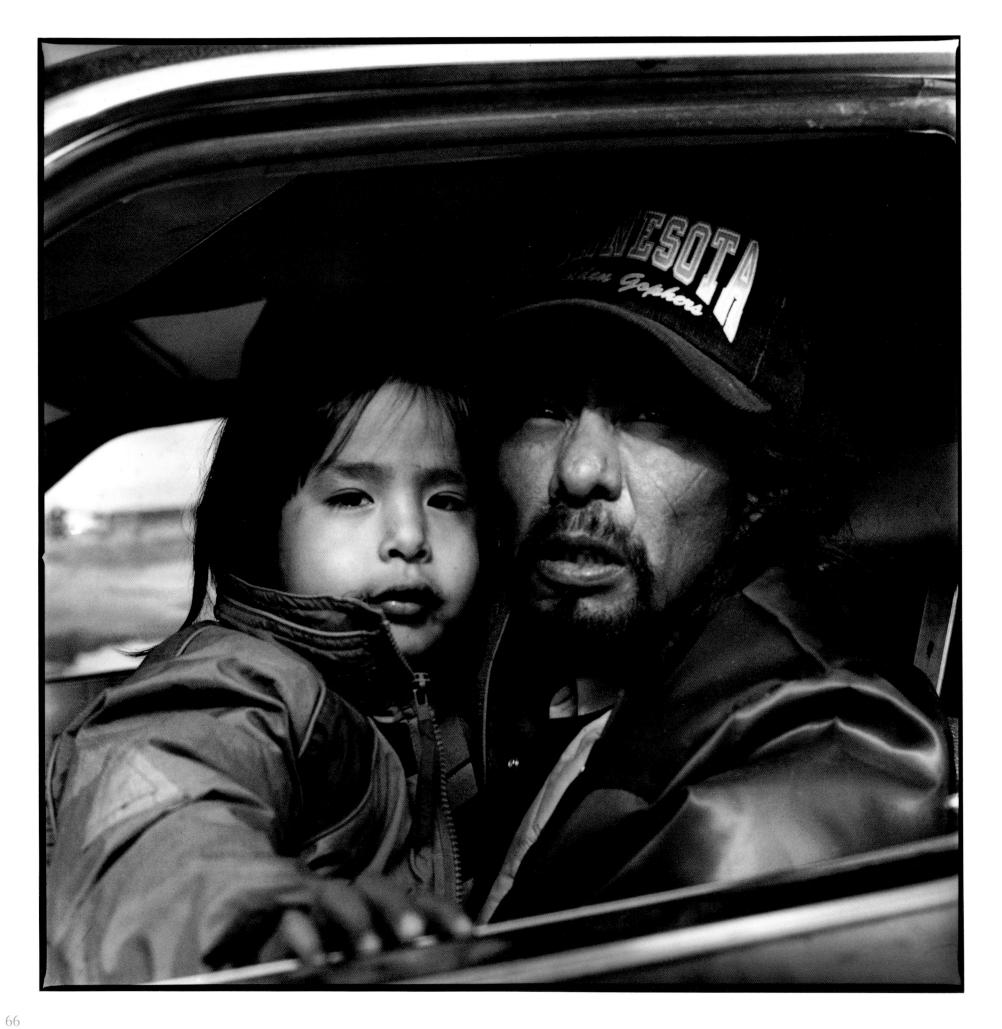

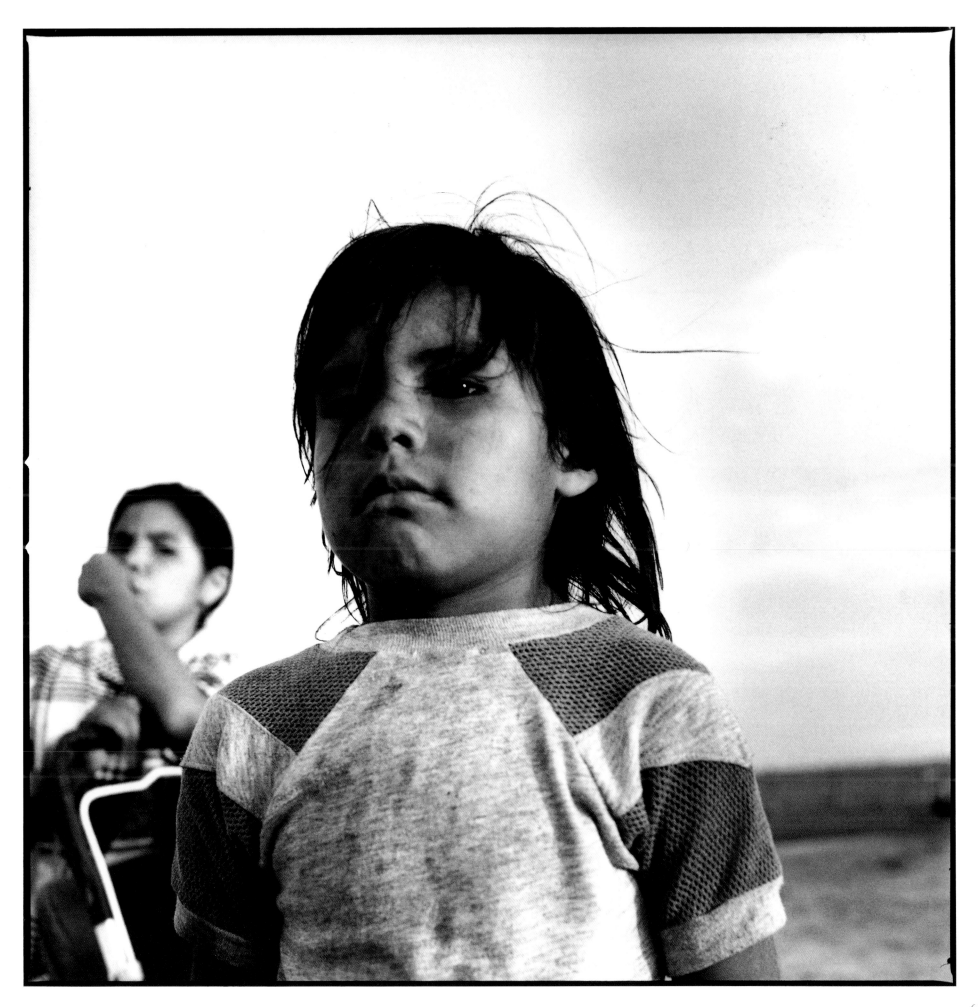

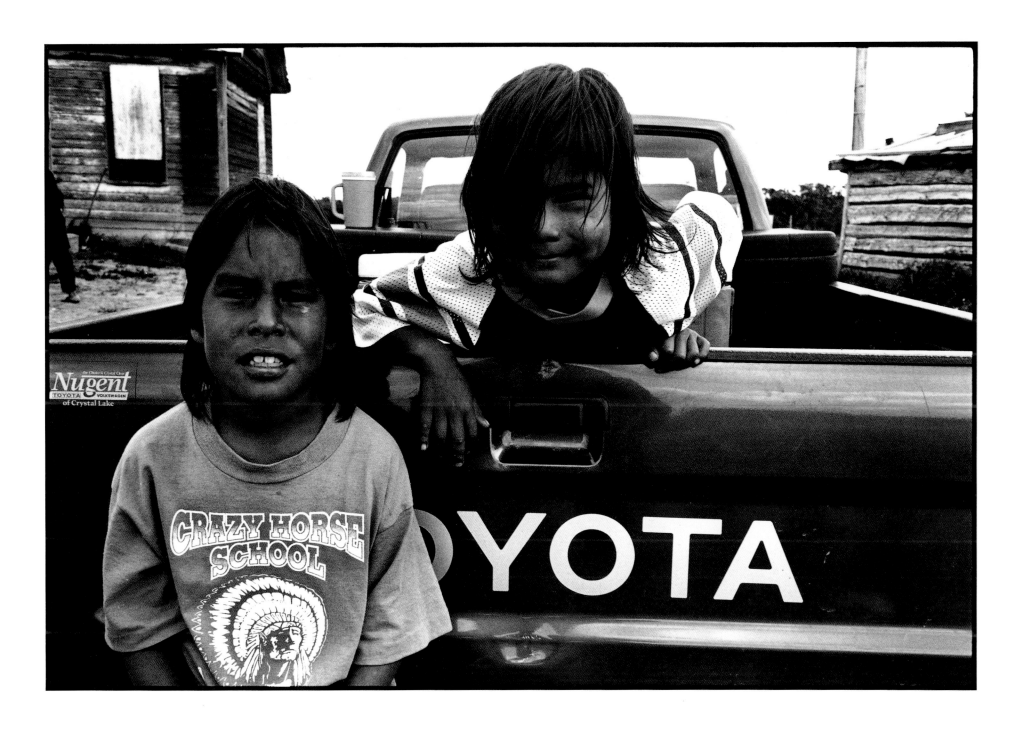

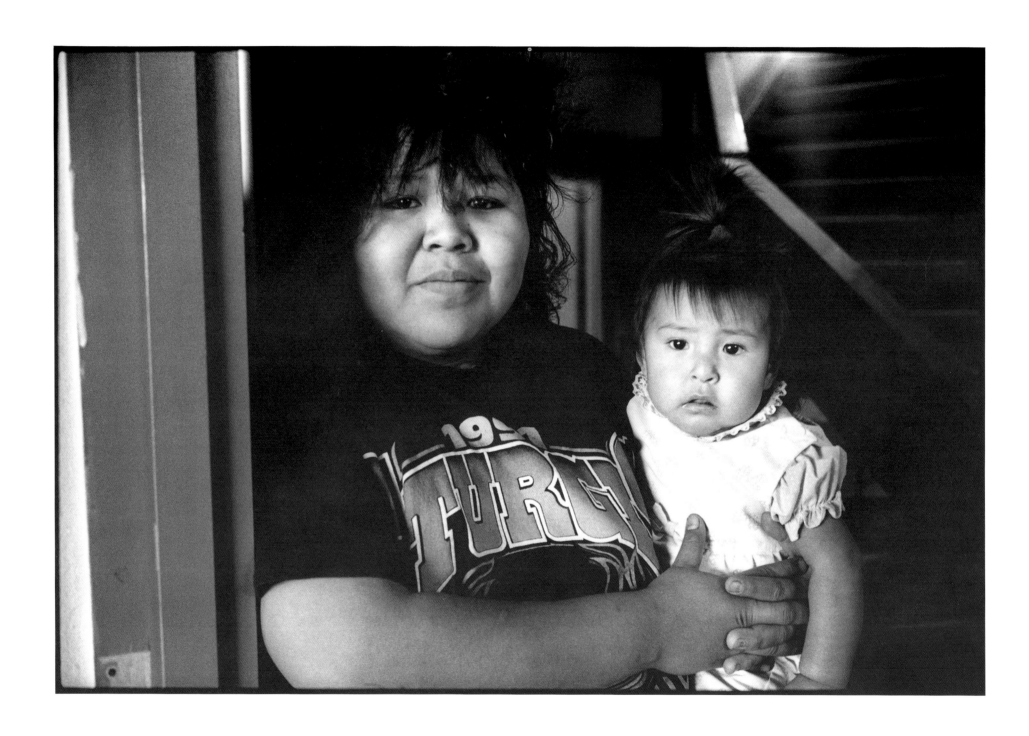

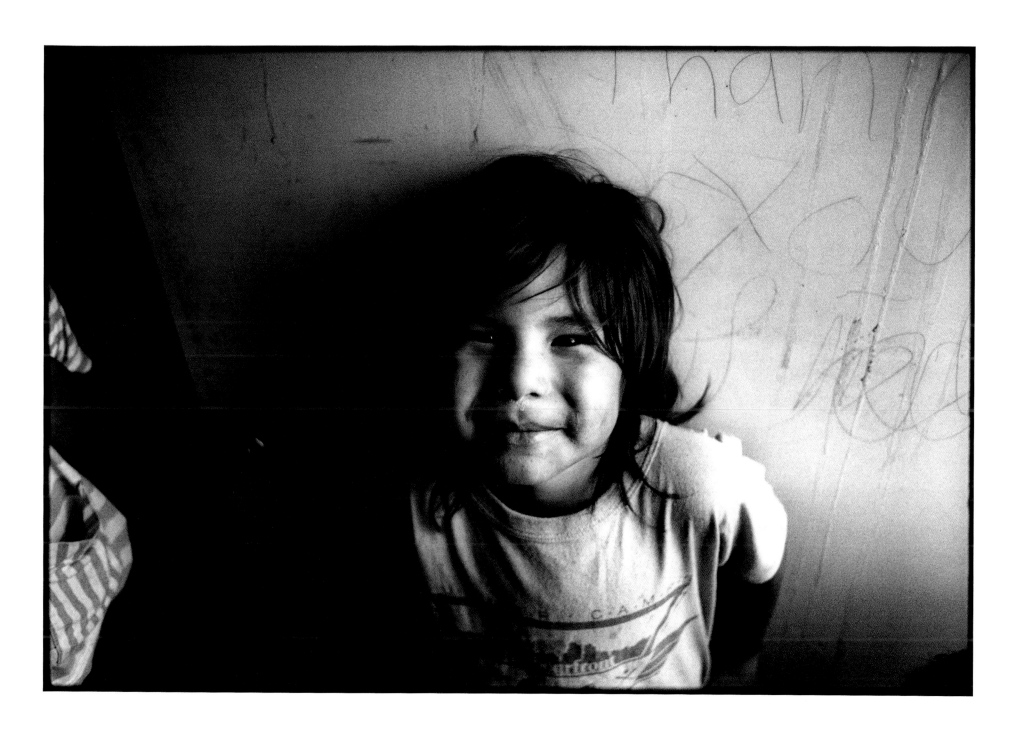

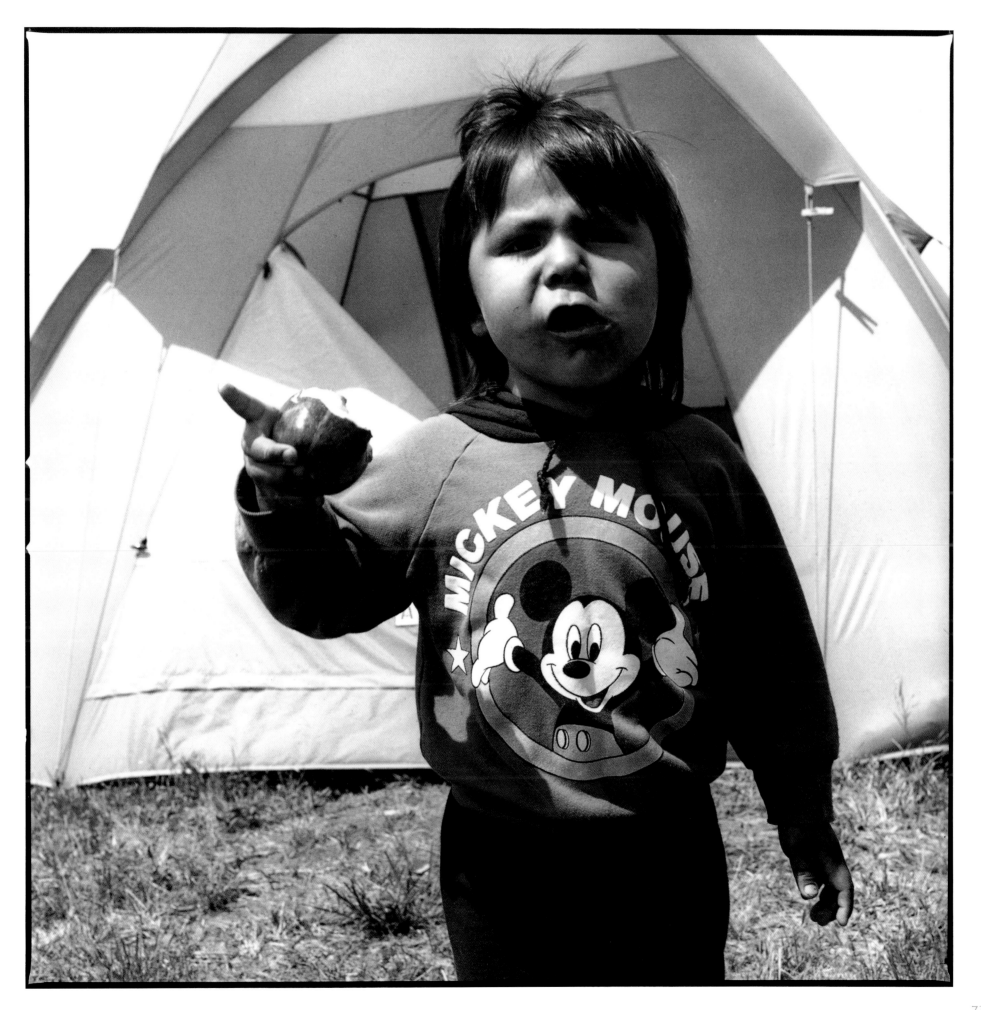

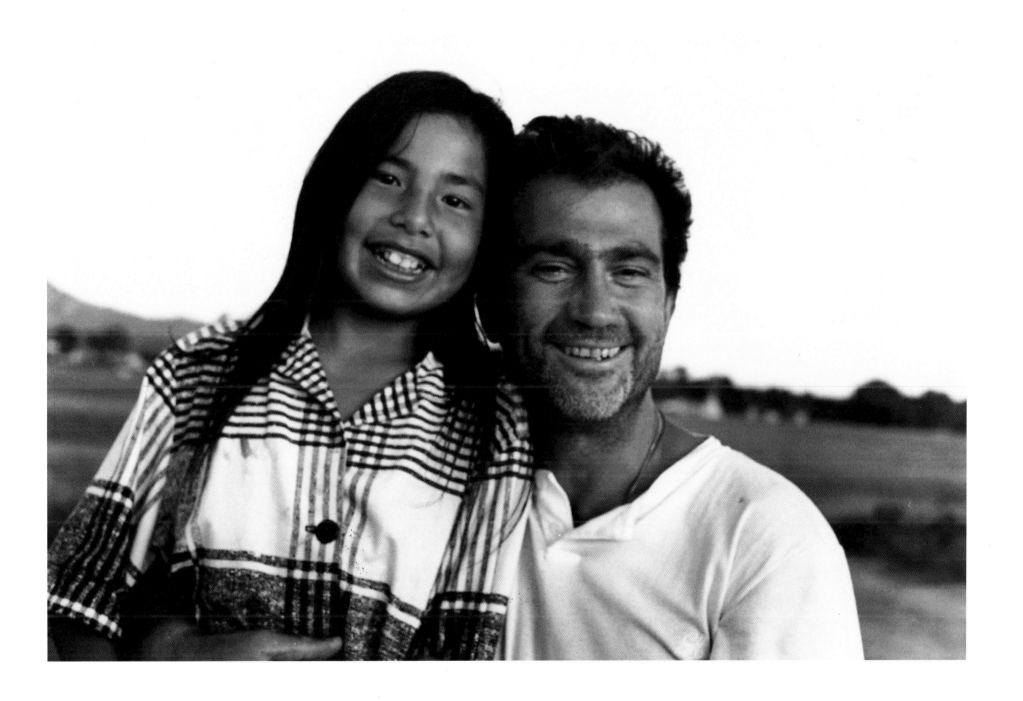

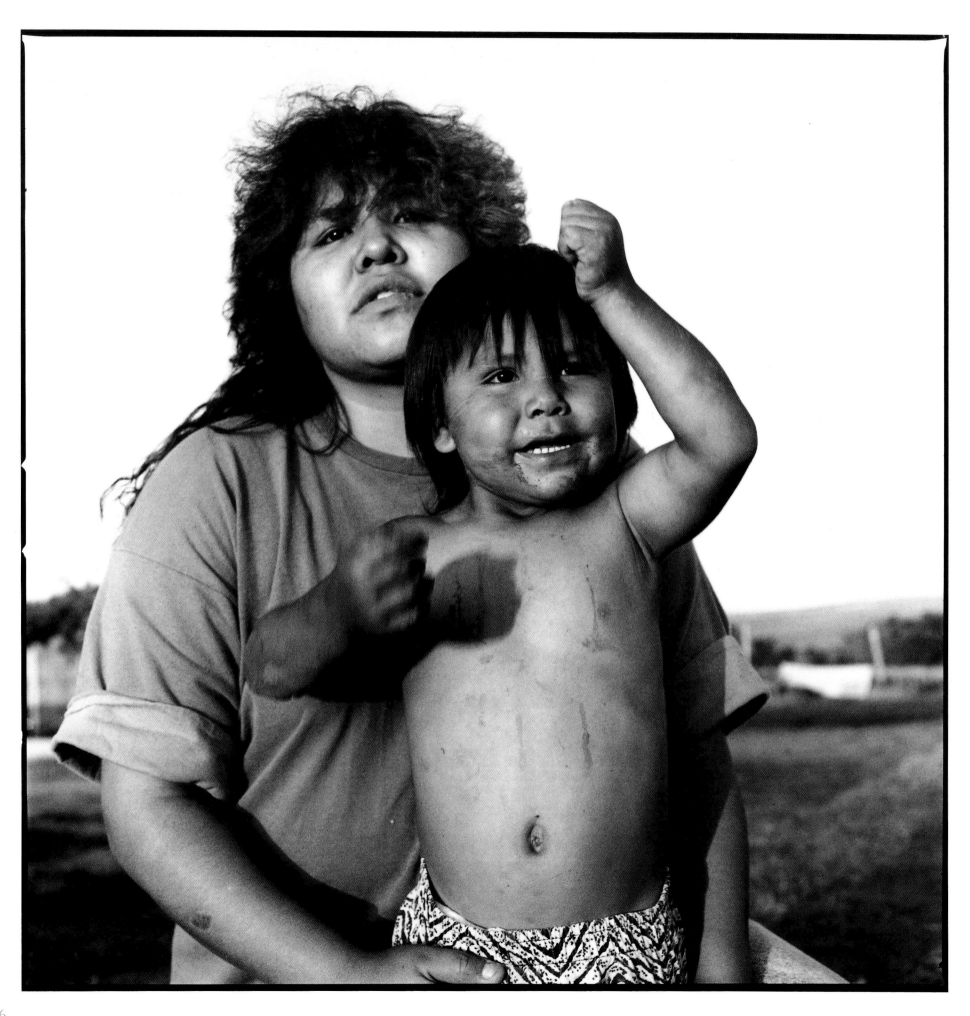

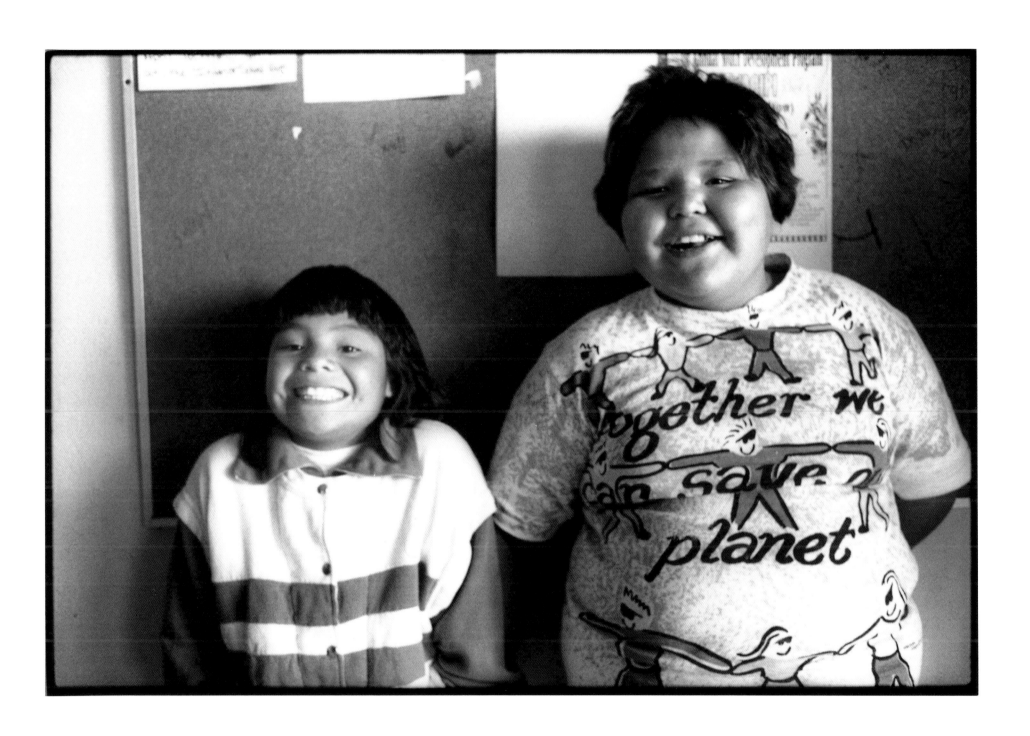

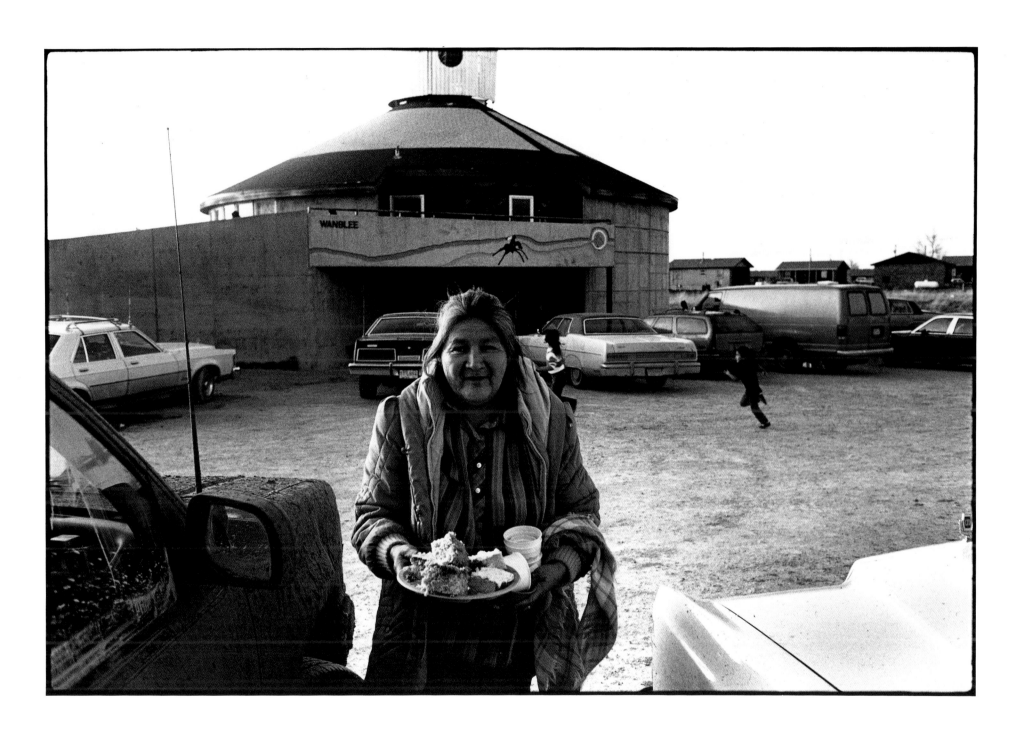

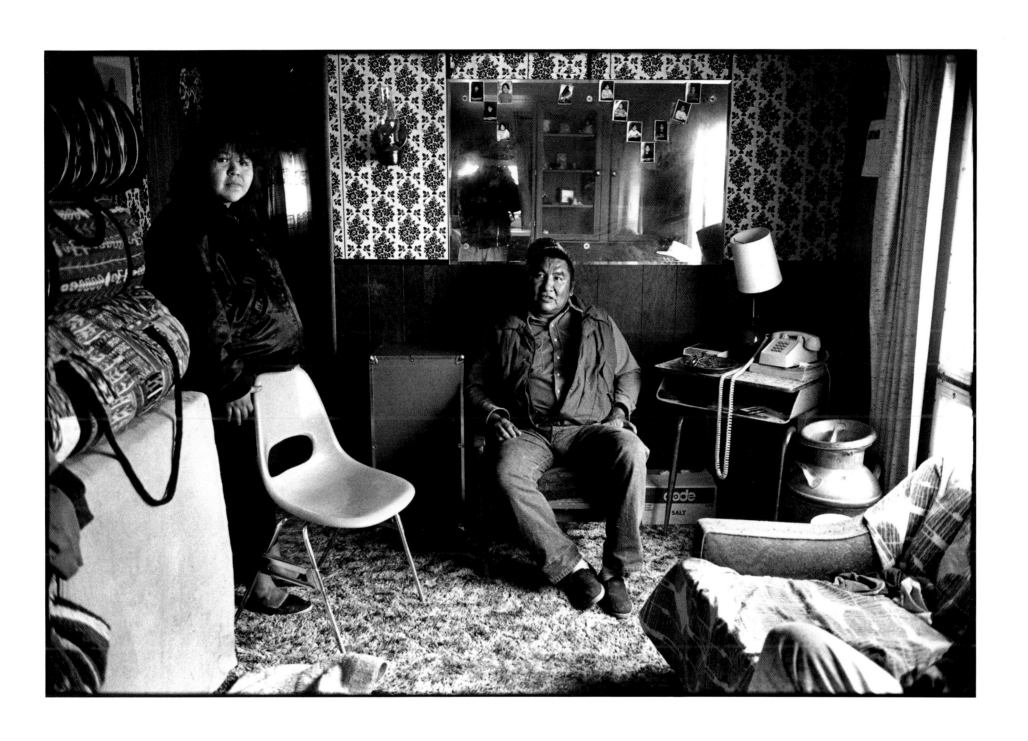

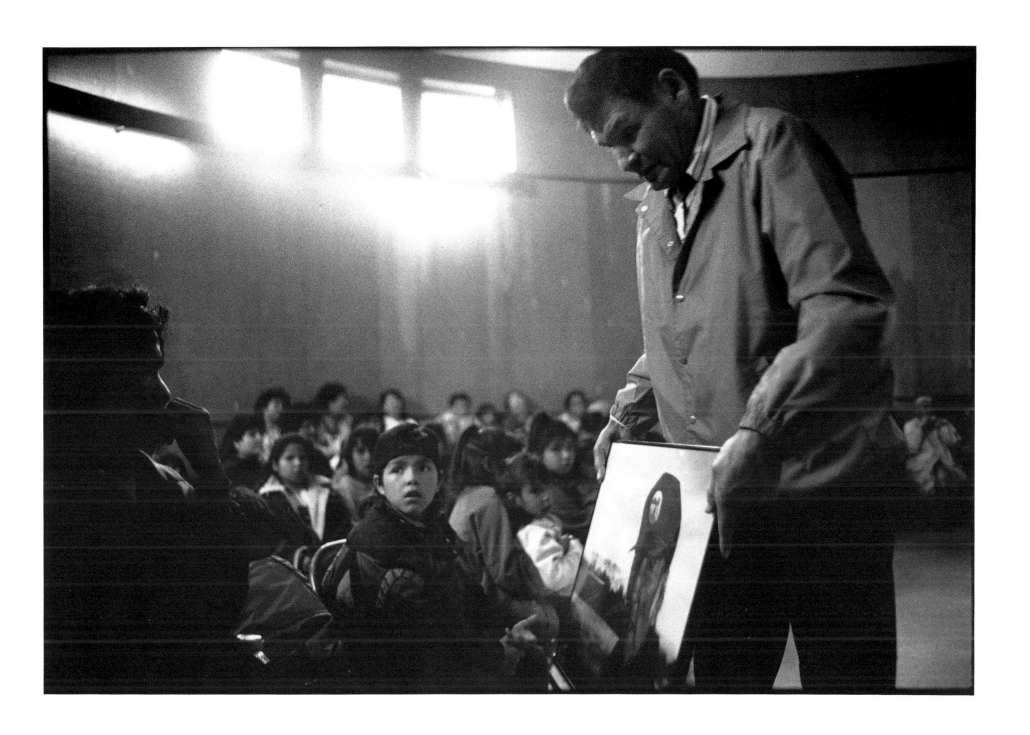

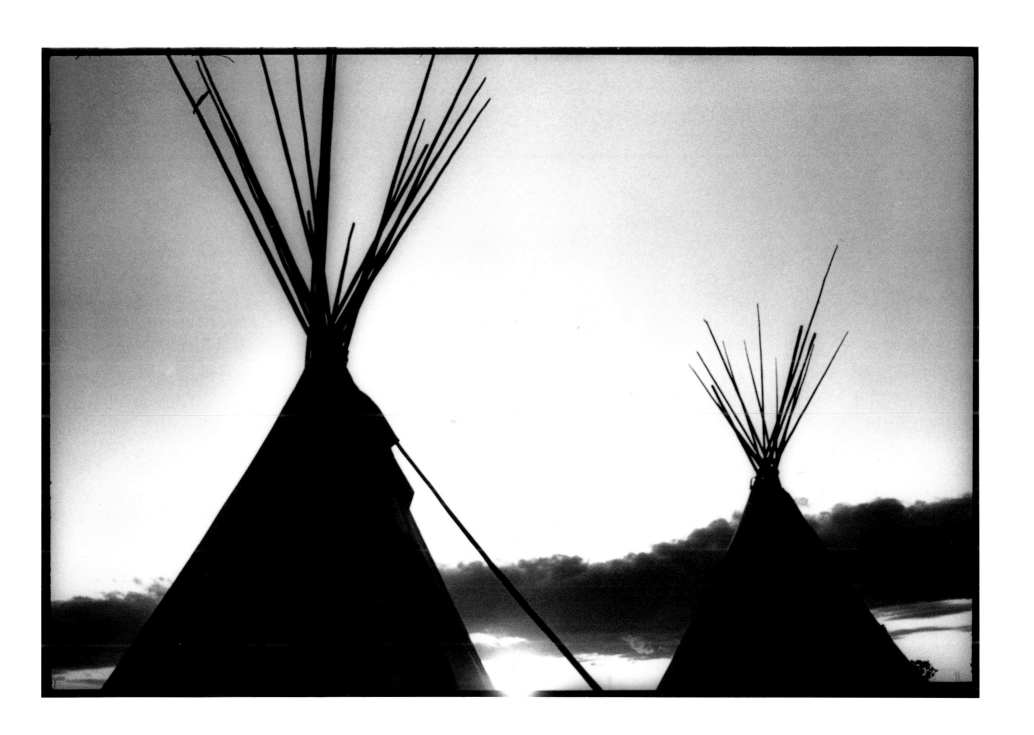

List of Photographs

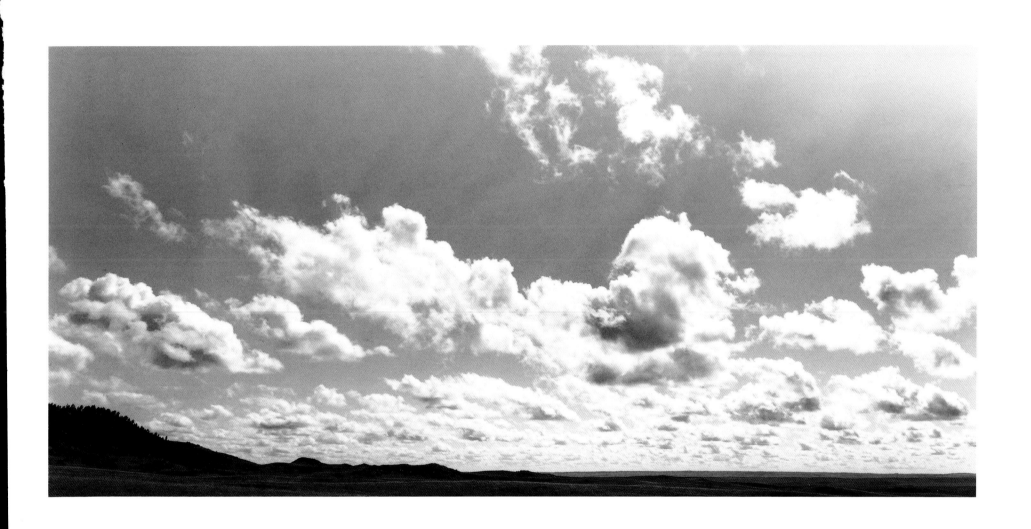

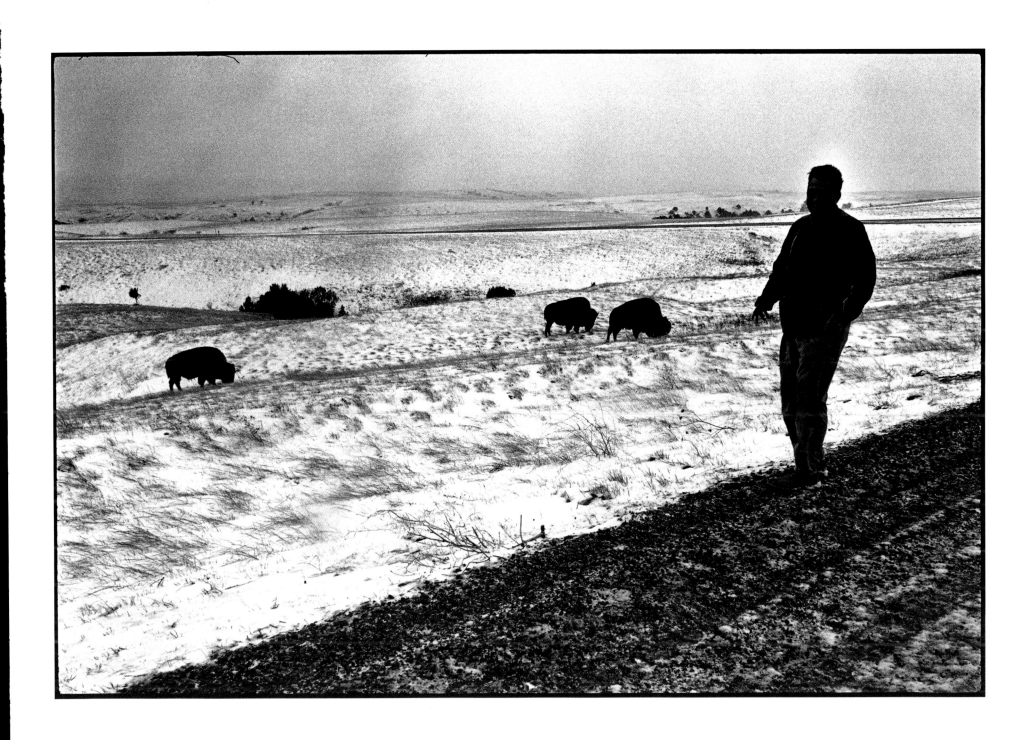

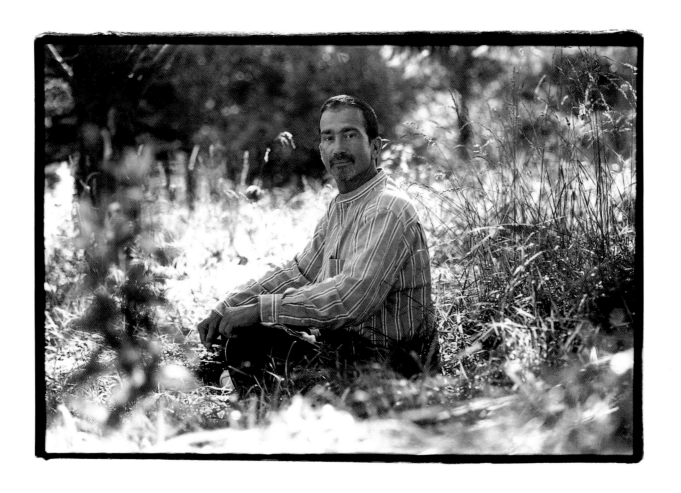

About the Photographer

Marco Ridomi was born in 1952 in Italy. After completing school, he moved to New York City to study photography and obtain a degree in fine art. At the age of 34, while training to become a professional photographer, he was diagnosed with a terminal disease. This changed his life dramatically, and he soon lost his will to live. In desperation, he began to search for a cure and eventually met a Native American healer named Godfrey Chipps. Through Godfrey and his family, Marco was led on a soul-searching journey to reclaim his health and spirit.

Presently, Marco is married and lives with his wife, Georgia, in Tuscany, where he owns and manages a farm of vineyards and olive groves. He is working on new photography projects and is planning to have children.

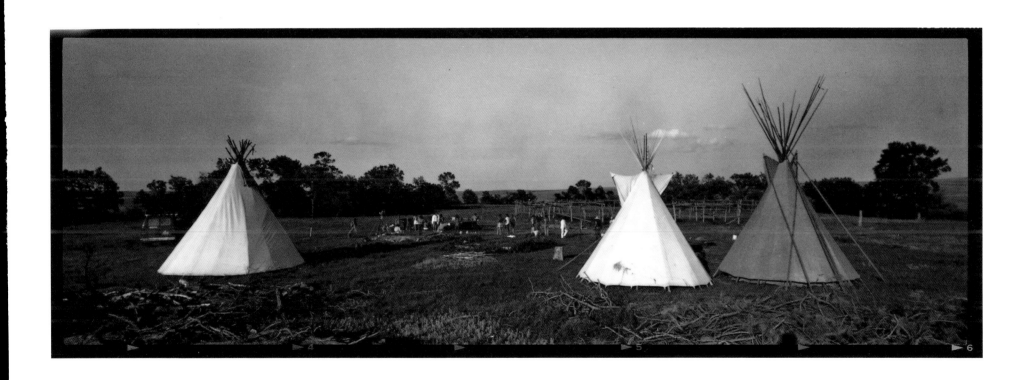

Designed and typeset by Susan Quasha.

The text is set in Baker Signet with Lithos titling.

The photographs in the book were shot with a Hasselblad,

a Leica M-6 3, and a Linhof 6x17 parabolic.

The film was TRI-X, *asa 400.*